A.11/89

AMERICAN PHOTOGRAPHY 4

AMERICAN PHOTOGRAPHY 4

The fourth annual of

American editorial, advertising and

poster, promotion, book,

and unpublished photography

Edited by Edward Booth-Clibborn

ABBEVILLE PRESS · PUBLISHERS · NEW YORK

Edward Booth-Clibborn *Editor*
Rip Georges *Designer*
Stephanie Van Dine *Project Director*
Amy Handy *Associate Editor*
Pamela Berry *Associate Designer*
Cathleen Munisteri *Associate Designer*
Leslie Hertzog *Assistant Designer*
Tom Carnase *Typography*
Matthew Rolston *Front jacket photograph*
Raymond Meier *Back jacket photograph*
Raymond Meier *Title page photographs*
Nigel Dickson *Jury photographs*

Special thanks to the School of Visual Arts
for providing the space and the equipment
for the annual American Photography judging
and to Esquire Magazine.

Captions and artwork in this book have
been supplied by the entrants. While every
effort has been made to ensure accuracy,
American Photography Inc. does not under
any circumstances accept any
responsibility for errors or omissions.

If you are a practicing photographer or
student and would like to submit work to
the next annual competition, the deadline
each year is November 10. For more
information write to:
American Photography Inc.
67 Irving Place
New York, NY 10003
(212) 460-5558

Copyright © 1988 Call For Entries
American Photography Inc.

Distributed in the United States and Canada:
Abbeville Press
488 Madison Avenue
New York, NY 10022
ISBN 0-89659-948-5
ISSN 0898-1124

Distributed in the United Kingdom
and World Direct Mail:
Internos Books
Colville Road
London W3 8BL, England
ISBN 0-89659-948-5
ISSN 0898-1124

Book trade for the rest of the world:
Hearst Books International
105 Madison Avenue
New York, NY 10016, USA

Printed and bound in Japan by Dai Nippon
Paper: 157 GSM Coated
Display type: Copperplate
Text type: Bembo

Typesetting: Carnase Inc.
New York City
New York

Copyright © 1988
by Polygon Trust

CONTENTS

INTRODUCTION

By Edward Booth-Clibborn

THE JURY

Ron Albrecht, Fabien Baron,
Richelle J. Huff, Karin Silverstein

ADVERTISING

Photographs for advertising in consumer, trade, and professional periodicals and brochures
Plates 1–14

BOOKS

Photographs for nonfiction books
Plates 15–23

EDITORIAL

Photographs for newspapers and
their supplements, and consumer, trade, and technical magazines and periodicals
Plates 24–107

PROMOTION

Photographs for promotional purposes, including technical and industrial literature,
brochures, and self-promotion pieces
Plates 108–114

UNPUBLISHED WORK

Commissioned but unpublished
photographs, and personal work produced by professionals and students
Plates 115–138

INDEX

Names and addresses of photographers;
names of designers, art directors, picture editors,
editors, publications, publishers, design
groups, advertising agencies, and clients

INTRODUCTION

This book contains some of the finest photographic images created for the American media during the last year or so. But don't take my word for it.

Over the last three years, *American Photography* has become recognized as the prime book of its kind published anywhere in the United States. Its contents—and its style—have been praised by critics and craftsmen alike. Its devotees are both the people whose photographs command our attention, and the people who commission photographs to arrest our attention.

Whichever side of the lens they are on, our supporters admire our single-minded commitment to achieving a simple objective: to bring together, year by year, a record of the most outstanding photography in America.

This year our jury spent a whole day at the School of Visual Arts in New York, weighing the merits and demerits of nearly three thousand images, more than twice as many submissions as last year. Their selection reflects their concerns. They have included much more black-and-white work, perhaps for its dramatic quality. And they have included the work of the unknown photographers of America as well as the known, and even the very well known. But that, I think, is part of our charm, and of our strength. We give no awards, believing that for most photographers, being included in this book is accolade enough.

If you would like to be among next year's select few, you'll find a Submission Form included with this book. In the meantime, I hope you enjoy this edition of *American Photography*—our way of recording the finest of American photography, year by year.

By Edward Booth-Clibborn

THE JURY

Ron Albrecht, Fabien Baron,

Richelle J. Huff, Karin Silverstein

Ron Albrecht joined Wells, Rich, Greene in 1986 as Executive Vice President Creative Director of the agency's Image Group, a division established to focus on selling products through emotion, style, and image. Prior to his position at Wells, Rich, Greene, Ron was the art director of *Elle* magazine, where he oversaw its American debut. He has also served as art director at *Self, Harper's Bazaar,* and *Essence*. Ron is a graduate of Pratt Institute, New York, and has received major awards from Art Direction, Print, Communication Arts, and the Society of Publication Designers.

FABIEN BARON

Fabien Baron, born in Paris in 1959, began
working for magazines at the age of seventeen,
after a year of art school. In 1979 he created
his own design company, which specialized in
redesigning magazines. He moved to New
York in 1983, where he has worked for *Self* and
GQ magazines. He also served as art direc-
tor at *New York Woman* magazine for its first
year and a half, and is currently the art
director for Barneys, New York.

Richelle J. Huff has been the art director
of *Progressive Architecture* for the past three years.
Prior to that she was associate art director
of *Cuisine* magazine. Before joining the
magazine world, she worked as the senior
graphic designer for the design firm M&Co.,
New York. She holds a master's degree in
design from the Cranbrook Academy of Art
in Bloomfield Hills, Michigan, and is cur-
rently designing a book on American graphic
and product designers.

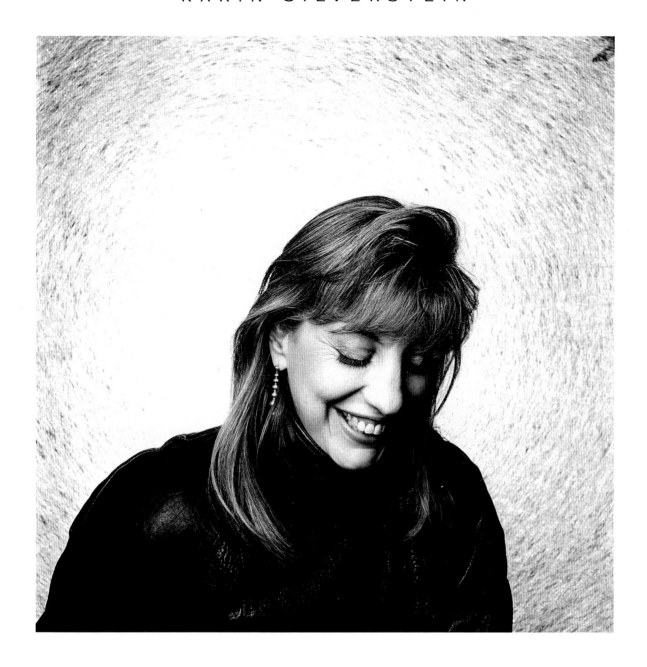

Karin Silverstein is currently entering her

fourth year as photo editor of *US* magazine.

Before joining *US,* she was photo editor of

Esquire, Rolling Stone, and *The Movies*. Karin's

freelance work includes consulting on ini-

tial issues of *New York Talk* and *Spy* magazines.

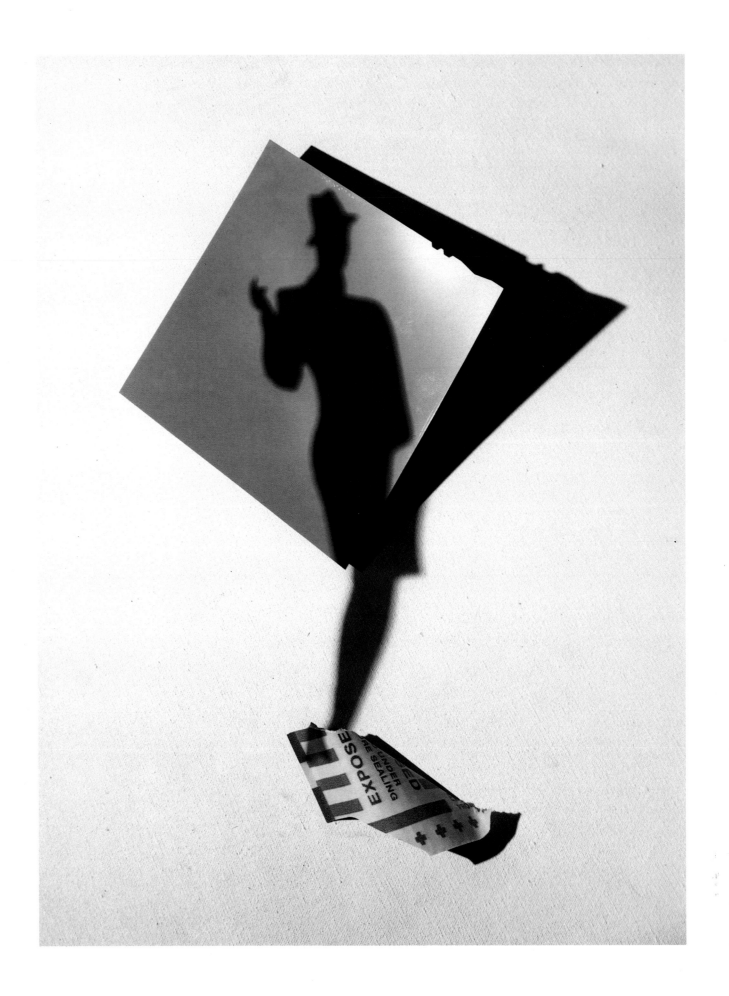

ADVERTISING

Photographs for advertising

in consumer, trade, and professional

periodicals and brochures

ART DIRECTOR *Parry Merkley*
WRITER *Gordon Bowen*
ADVERTISING AGENCY *Ogilvy & Mather, New York*
CLIENT *American Express,*
July–August 1987

Cardmembers Wilt Chamberlain
and Willie Shoemaker, Elmore Leonard,
Amy Grant, Ray Charles,
and Candice Bergen were all captured
by Annie Leibovitz for the
American Express personal card campaign.

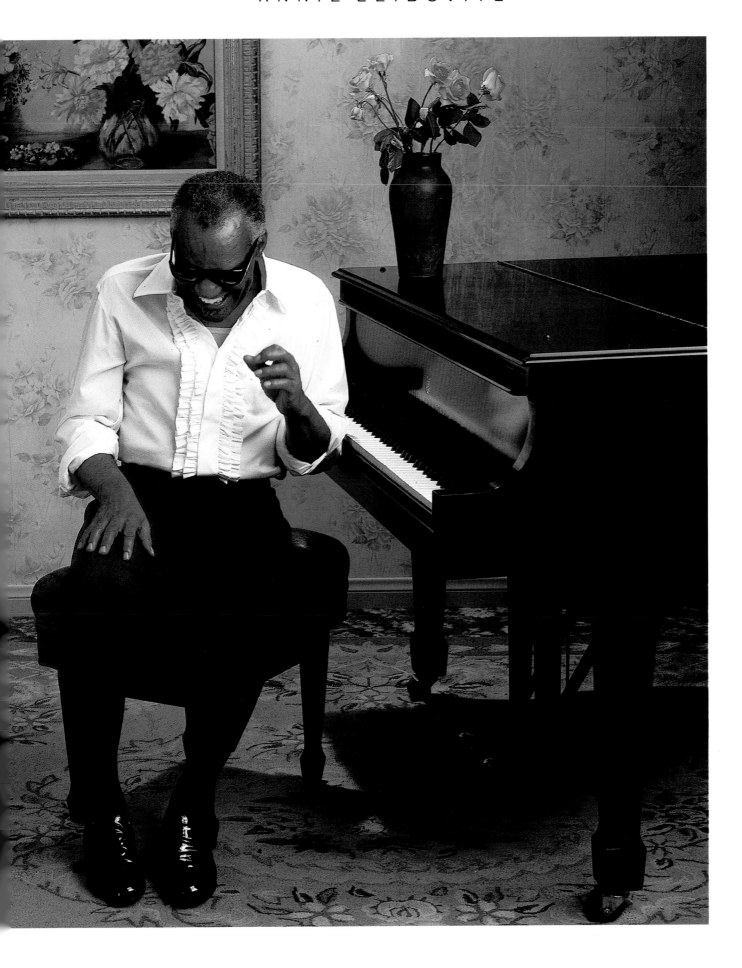

plate **1**

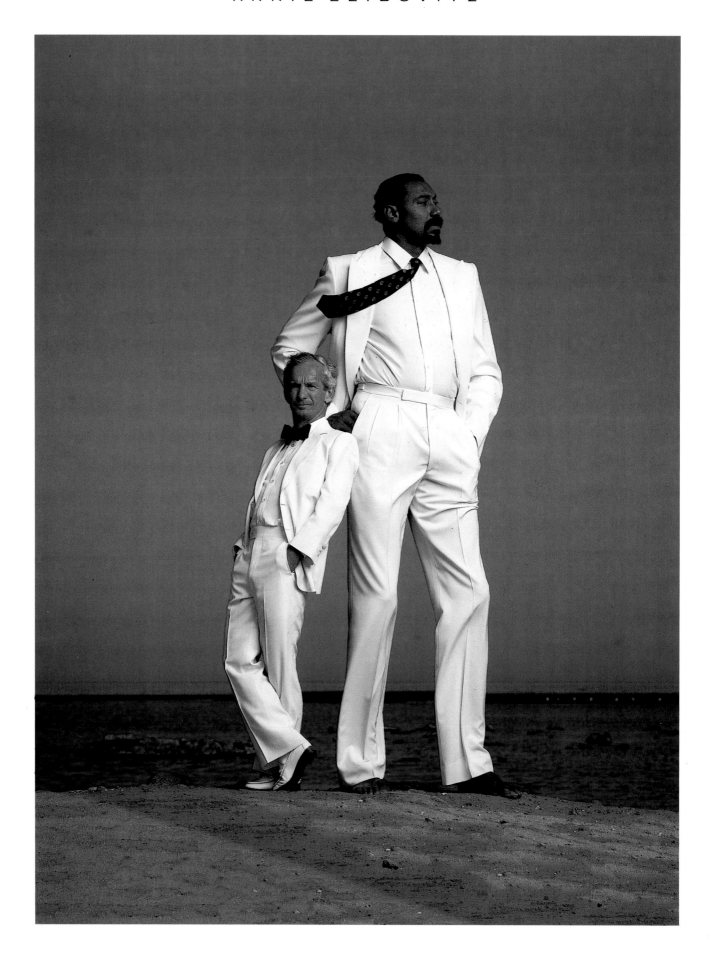

plate **2**

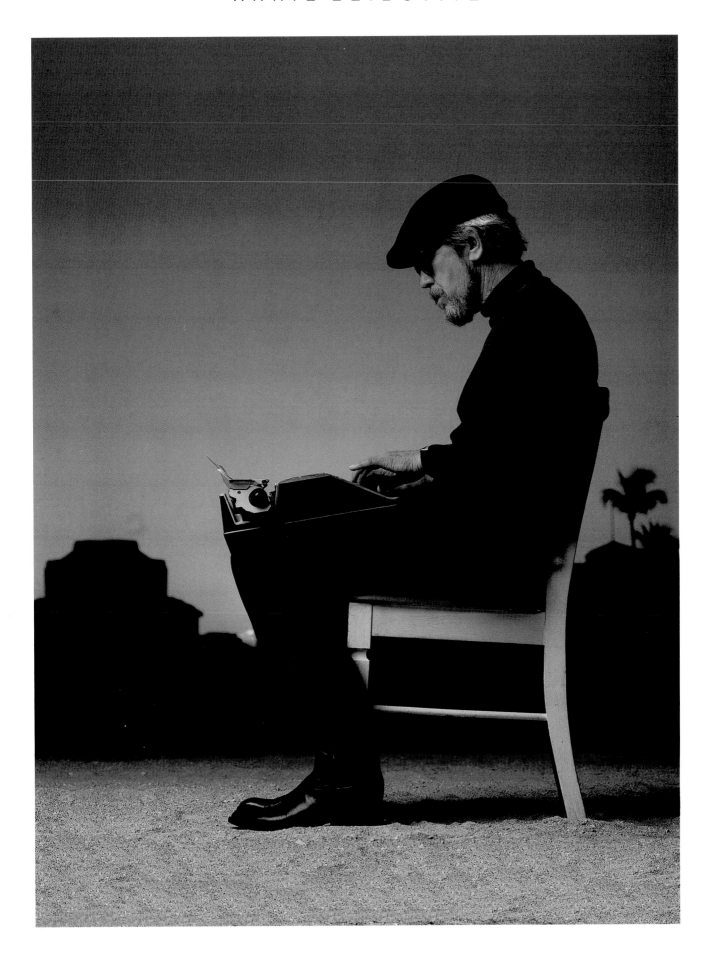

plate 3

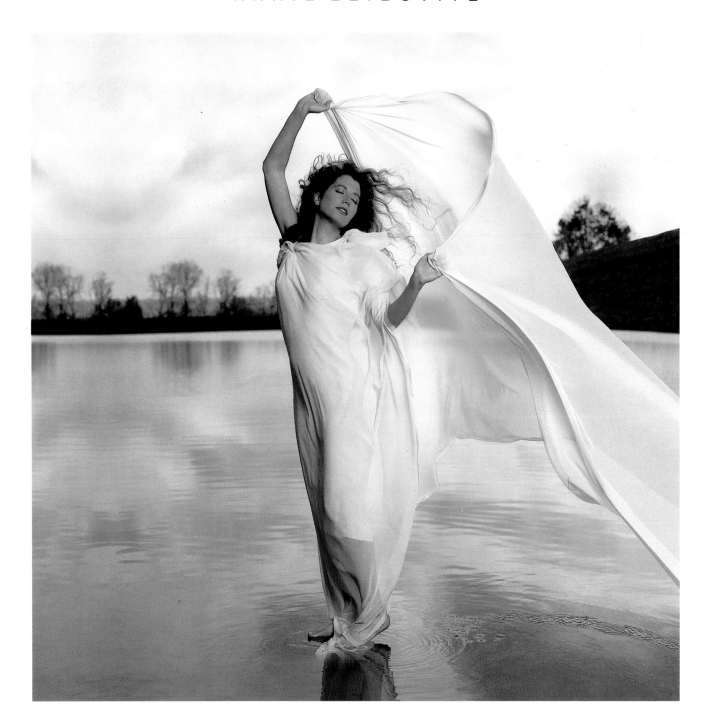

plate **4**

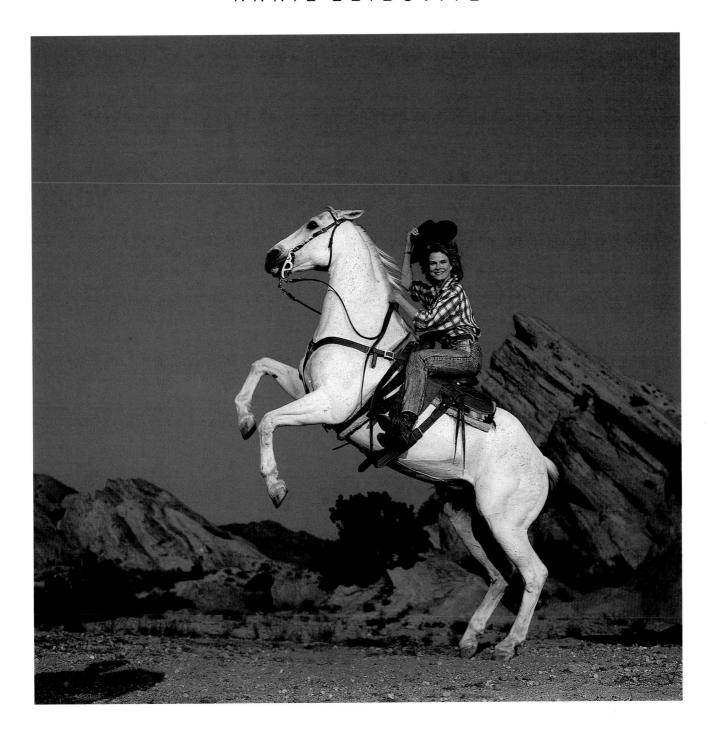

plate 5

plate **6**

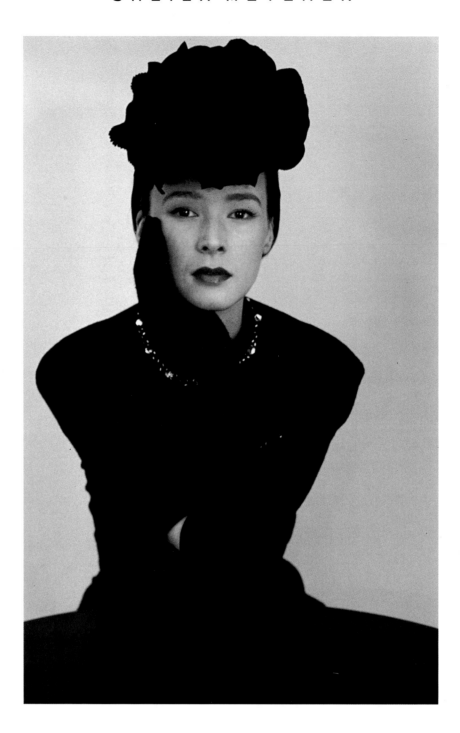

ART DIRECTOR *Tohji Murata*
DESIGN GROUP *Strawberry Fields*
CLIENT *Sutseso; World Company Ltd.,*
July 1987

The Sutseso Autumn
Collection catalog included
these three photographs.

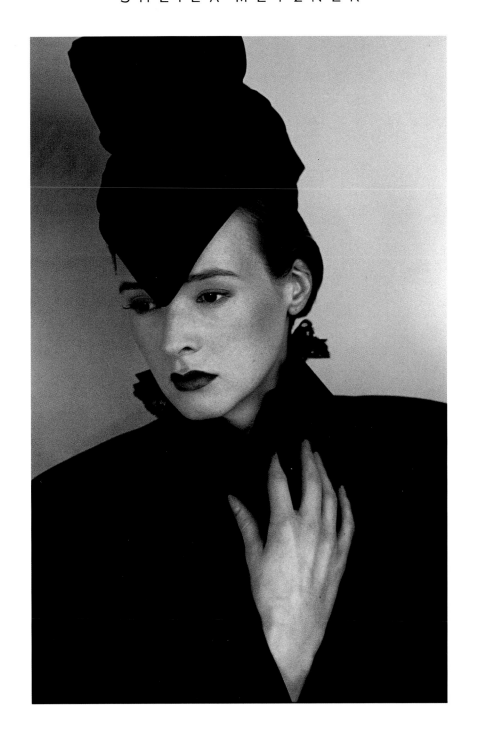

plate **7**

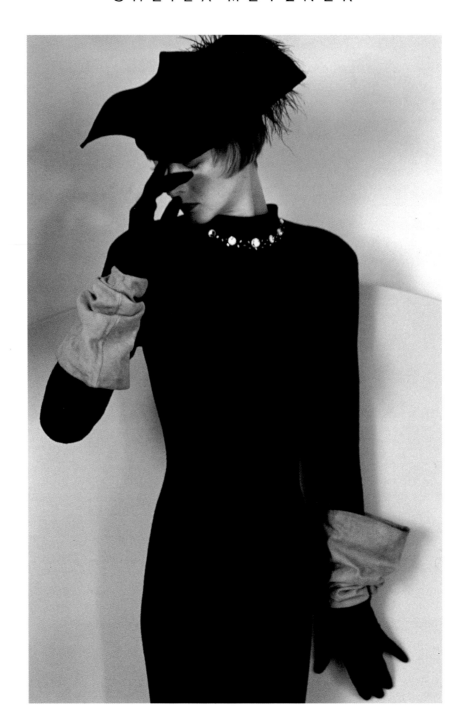

plate **8**

SHEILA METZNER

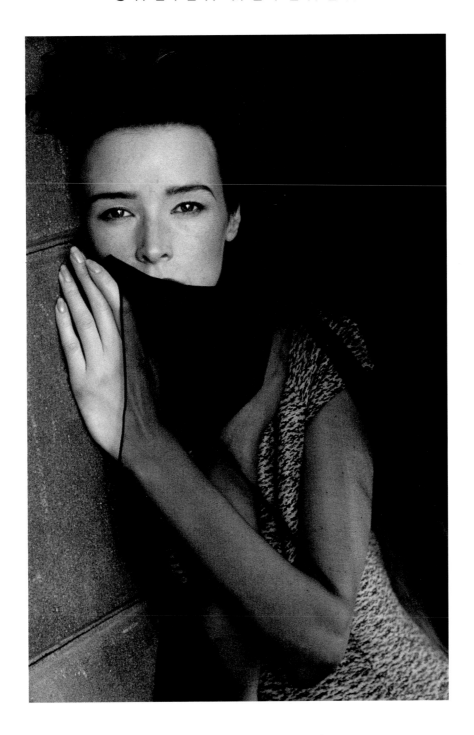

plate **9**

ART DIRECTOR *Tomohiko Nagakura*
DESIGN GROUP *Sutseso; World Company Ltd.,*
September 1987

These three photographs
were used in the Sutseso Winter
Collection catalog.

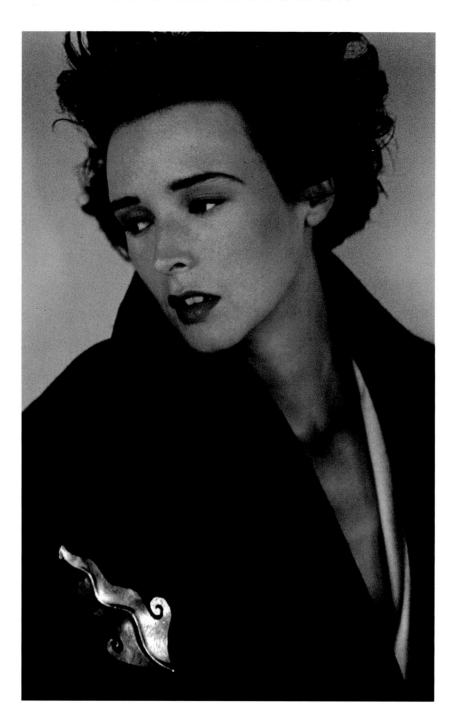

plate **10**

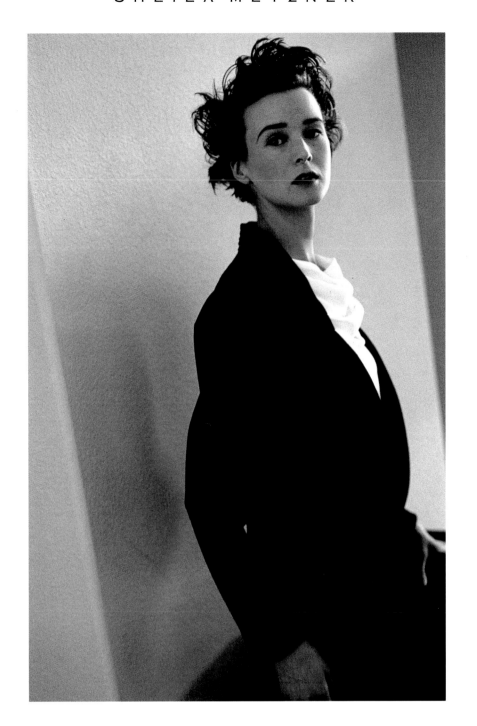

plate **11**

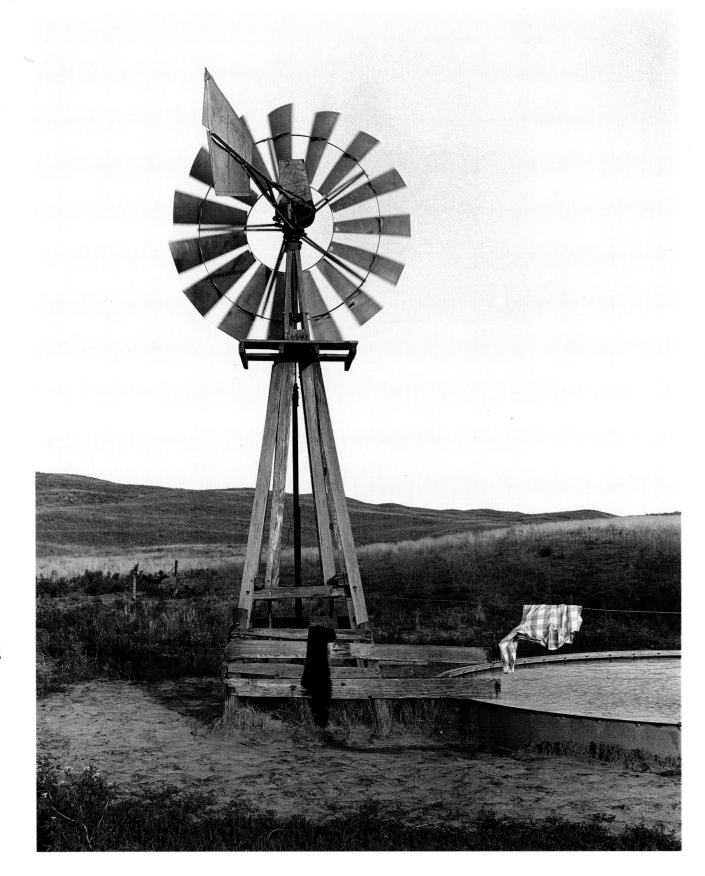

plate 12

ART DIRECTOR *Hisao Sugiura*
DESIGN GROUP *Studio Super Compass*
CLIENT *Yohji Yamamoto, November 1987*

*The catalog promoting Japanese designer Yohji
Yamamoto's bed and bath line
featured photographs shot on a Nebraska ranch.*

plate **13**

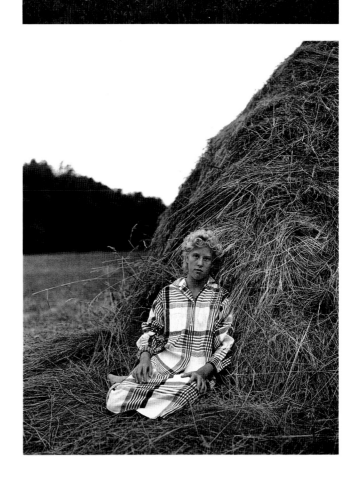

plate **14**

BOOKS

Photographs for nonfiction books

plate **15**

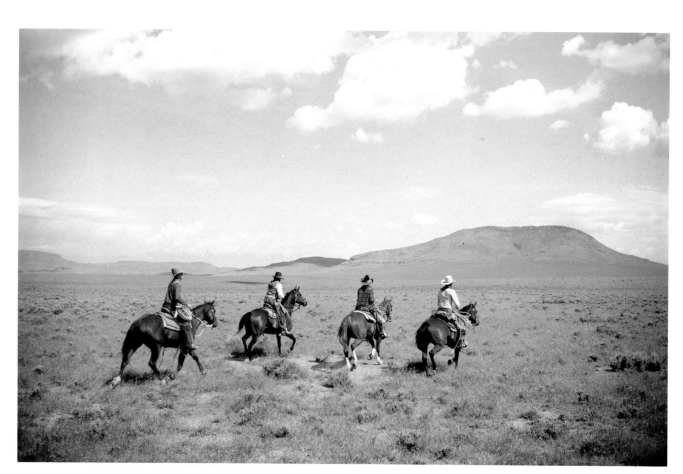

DESIGNER *Eleanor Caponigro*
EDITOR *Russell Martin*
TITLE *"Buckaroo" Images from the
Sagebrush Basin*
PUBLISHER *Little, Brown and Company, Inc.,
1987*

*Kurt Markus's ten-year
experience with the people of the Great
Basin evolved into a book.
Seen here, four riders at Whitehorse
Ranch Field, Oregon.*

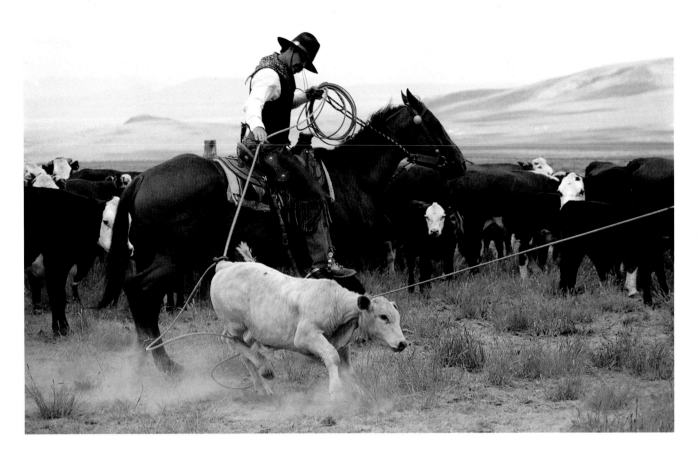

plate **16**

Roping a calf at Whitehorse Ranch.

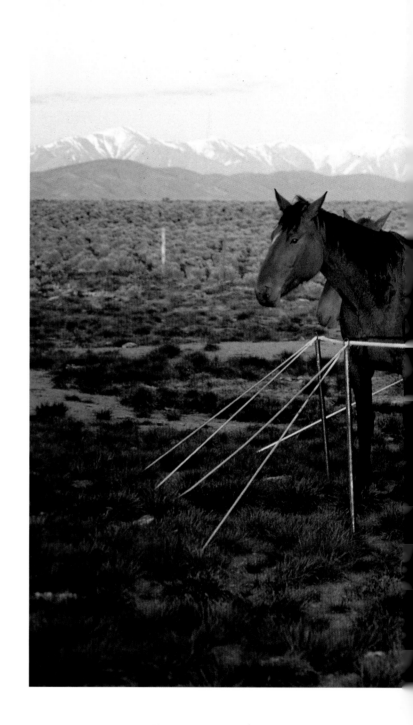

Horses in a rope corral,
Russell Ranches, Eureka, Nevada.

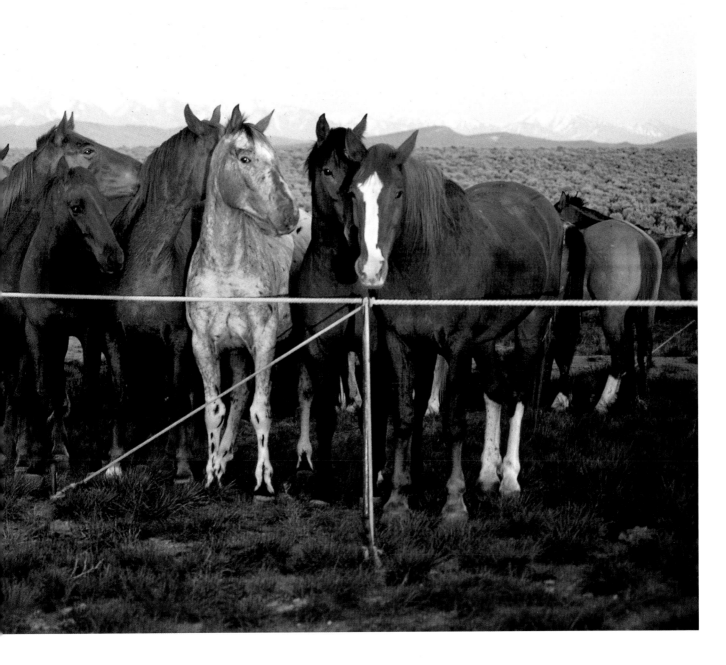

plate **17**

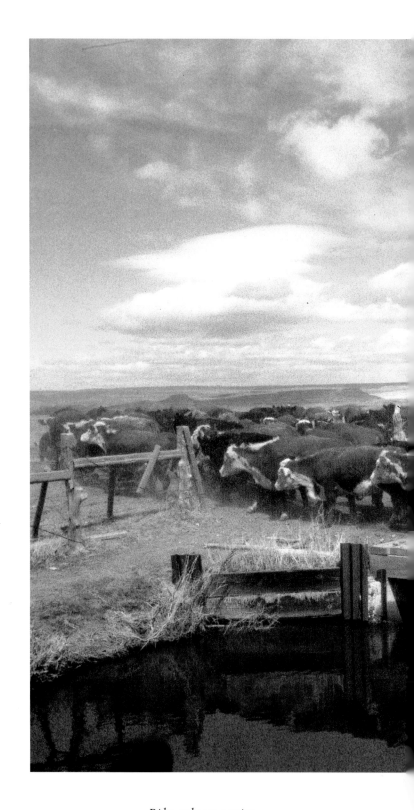

*Rider and cows crossing
a small creek at MC Ranch,
Adel, Oregon.*

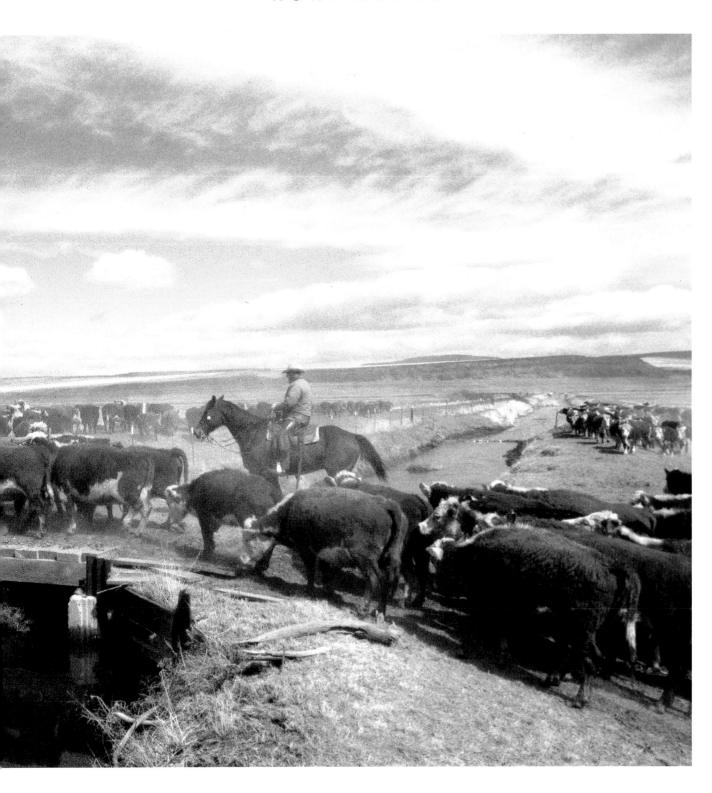

plate 18

plate **19**

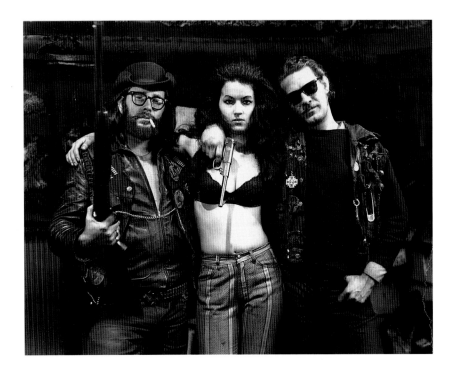

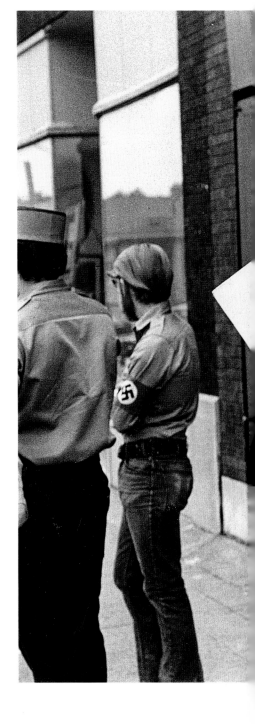

DESIGNER *Dennis Darling*
ART DIRECTOR *Dennis Darling*
EDITORS *Susan Stone, Dana Scragg*
TITLE *Desperate Pleasures*
PUBLISHER *Dorsoduro Press*

Dennis Darling's book
Desperate Pleasures includes this shot
of "Hell's Henchman,"
as well as "Rockwell Hall—Five
Men and a Swastika,"
and "Dead Bull—Barcelona, Spain."

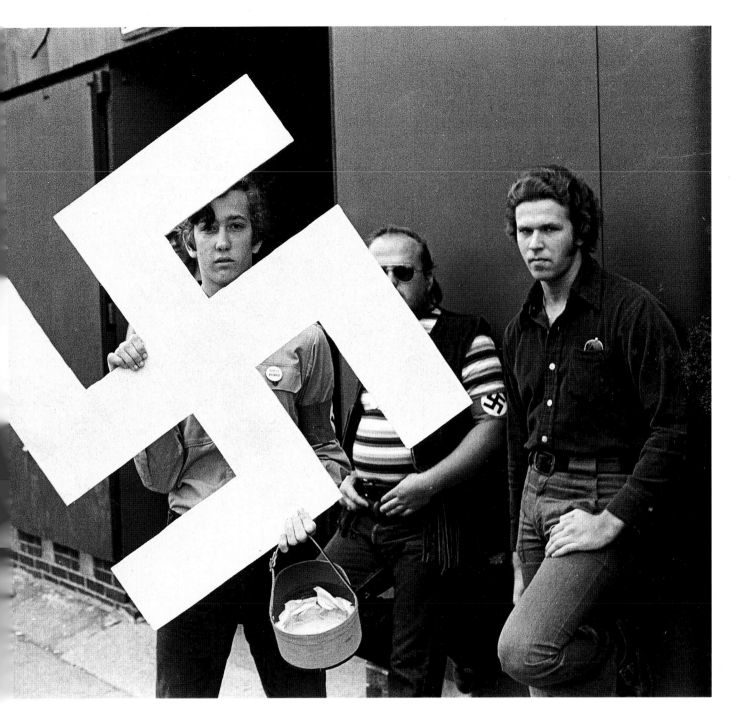

plate 20

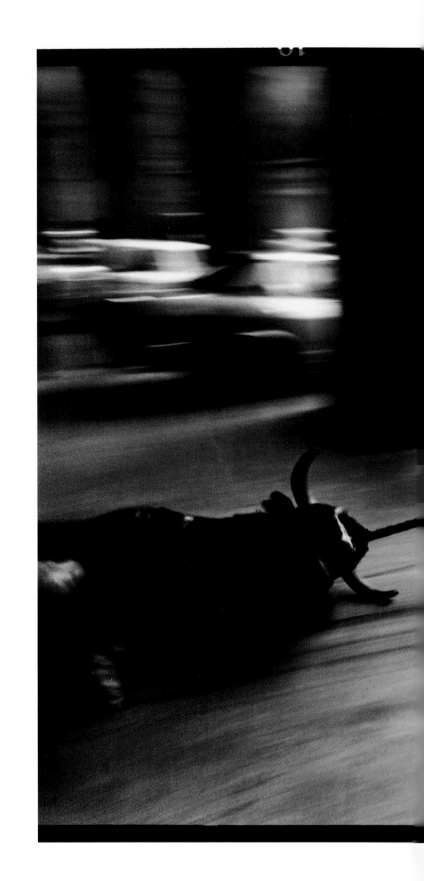

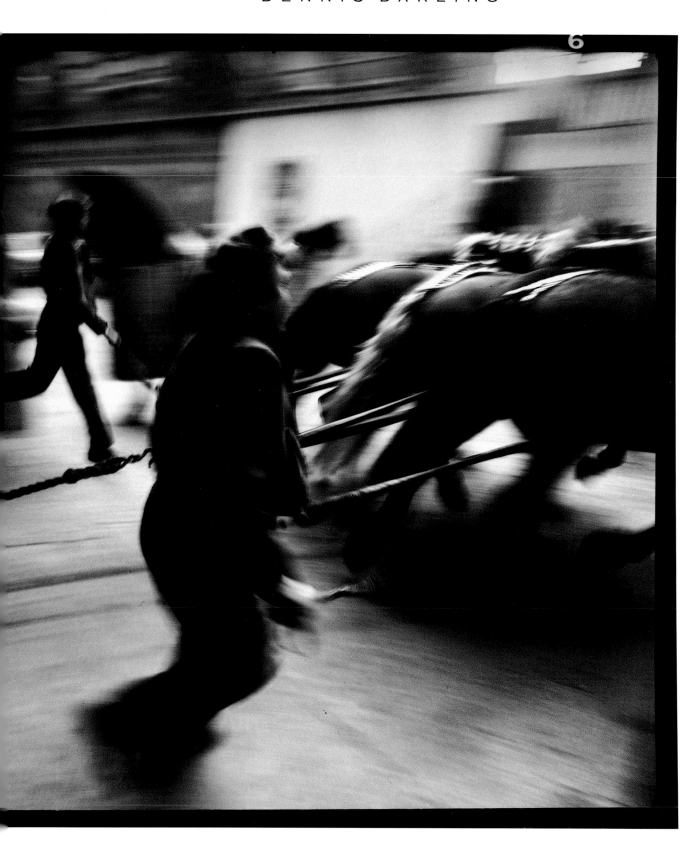

plate **21**

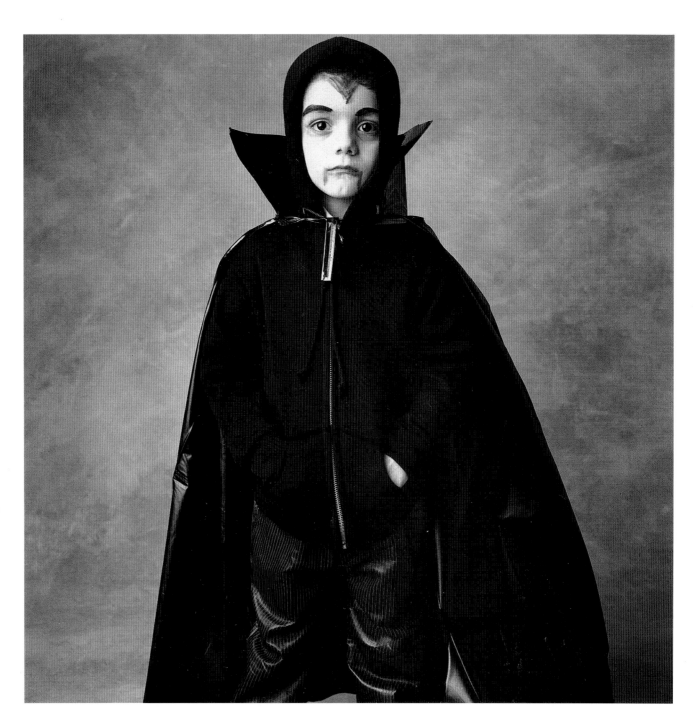

plate **22**

DESIGNER *Bill Sosin & Associates*
ART DIRECTOR *Bill Sosin & Associates*
TITLE *Halloween in Bucktown*
PUBLISHER *Man Mountain Publishing, 1987*

*Marc Hauser spent several
Halloweens photographing trick-or-treaters
in Chicago's Bucktown
neighborhood, then developed these images
into a book with text by
Cindy Sims. Shown here are "Dracula"
and "Old Hag."*

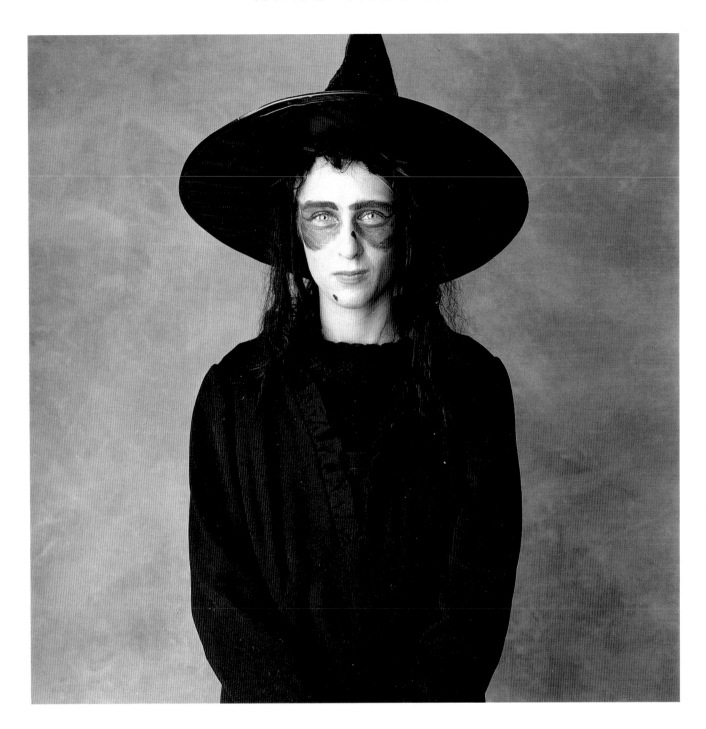

plate **23**

EDITORIAL

Photographs for

newspapers and supplements,

and consumer, trade,

and technical magazines

and periodicals

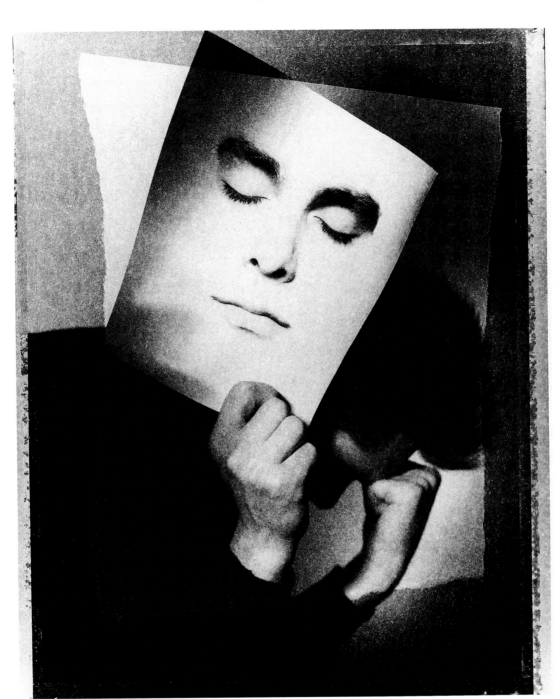

plate **24**

ART DIRECTOR *D. J. Stout*
PUBLICATION *Texas Monthly*
PUBLISHER *Texas Monthly, Inc.*

*The problems of living
in an era of growing social restrictions
were considered in
"The No Decade," an article by David Seeley.
June 1987.*

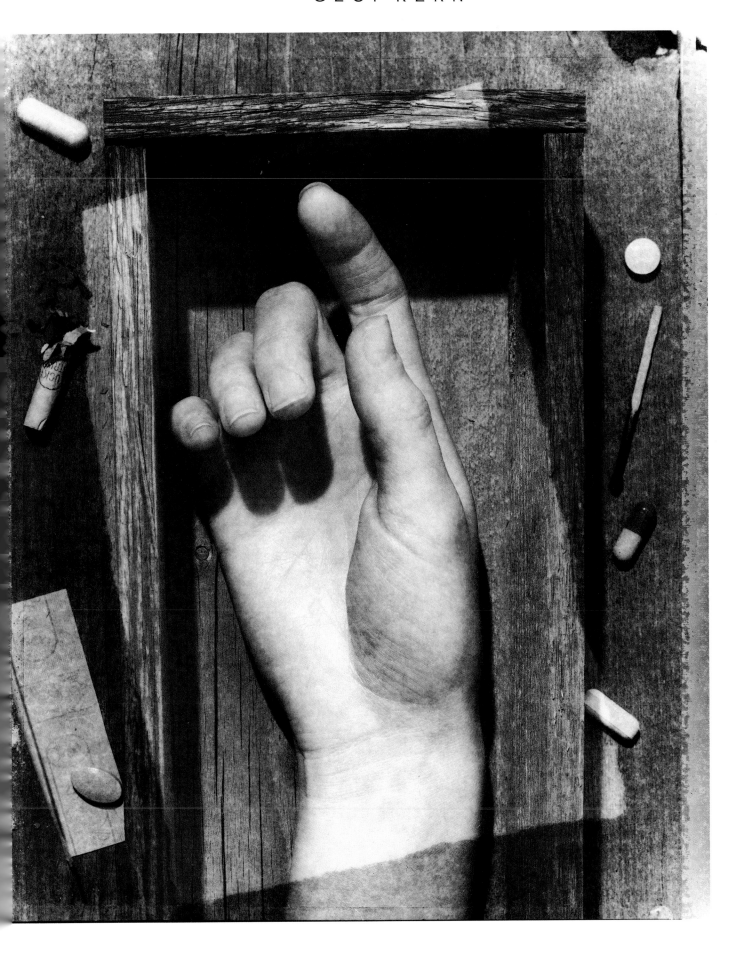

plate 25

plate **26**

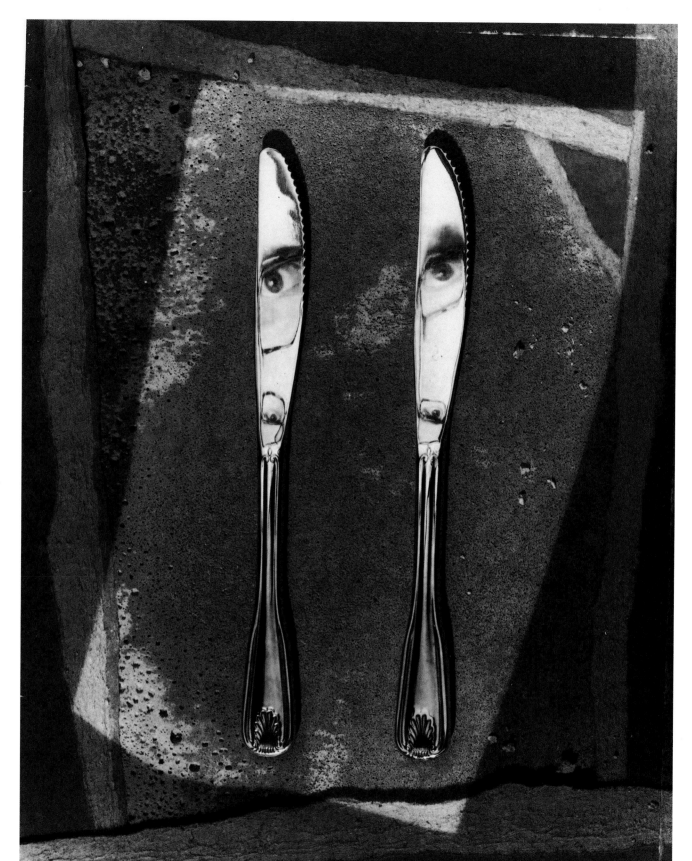

PUBLICATION *Rolling Stone*
PUBLISHER *Straight Arrow Publishers, Inc.*

"To the Manner Born"
discussed recent studies on the mannerisms
of identical twins.
October 1987.

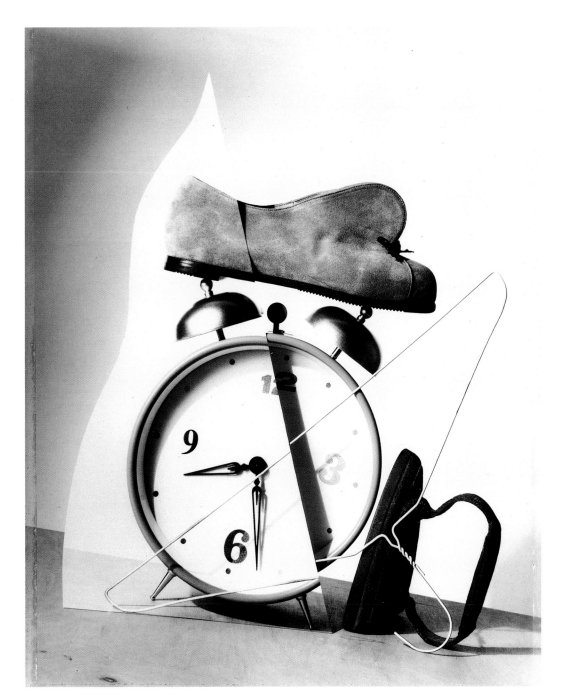

plate **27**

ART DIRECTOR *Geof Kern*
PUBLICATION *Detour Magazine*
PUBLISHER *Detour Magazine, Inc.*

*This still life appeared
in the fashion article "If the Shoe Fits."
December 1987.*

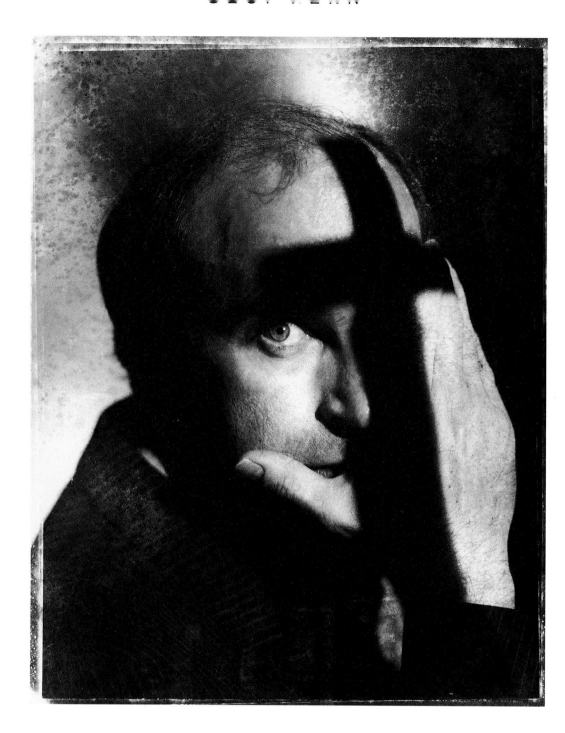

plate **28**

ART DIRECTOR *D. J. Stout*
PUBLICATION *Texas Monthly*
PUBLISHER *Texas Monthly, Inc.*

"The Sins of Walker Raily"
investigated a former Dallas minister
suspected of strangling
his wife and fleeing with his secretary to
California. The article
featured this dramatic portrait.
September 1987.

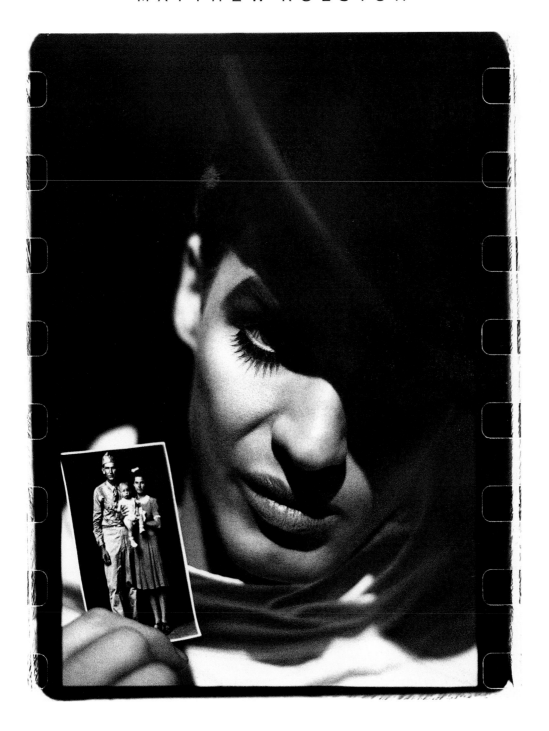

plate 29

ART DIRECTOR *Derek Ungless*
PICTURE EDITOR *Laurie Kratochvil*
PUBLICATION *Rolling Stone*
PUBLISHER *Straight Arrow Publishers, Inc.*

*The striking contrast
between an old family photograph
and a well-known movie
character introduces A Clockwork Orange—
The Missing Chapter, by
Anthony Burgess. March 1987.*

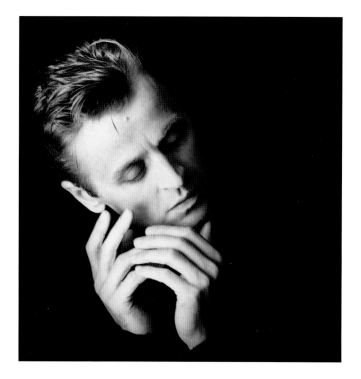

plate **30**

ART DIRECTOR *Fred Woodward*
PICTURE EDITOR *Laurie Kratochvil*
PUBLICATION *Rolling Stone*
PUBLISHER *Straight Arrow Publishers, Inc.*

Mikhail Baryshnikov
is portrayed in two photographs for
a Rolling Stone interview
by Nancy Collins. October 1987.

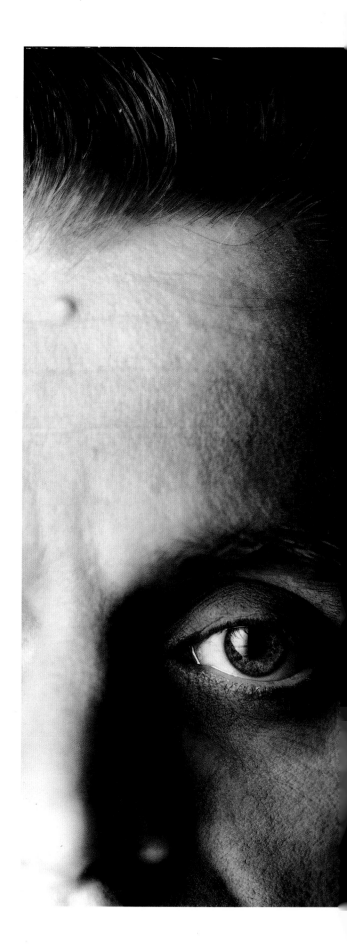

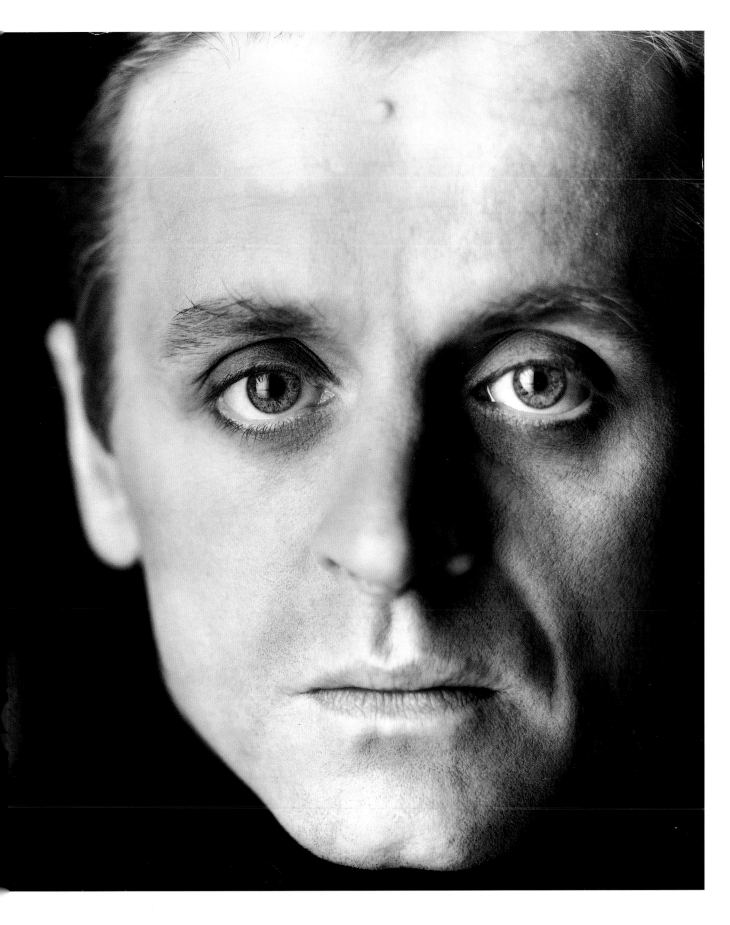

plate **31**

MATTHEW ROLSTON

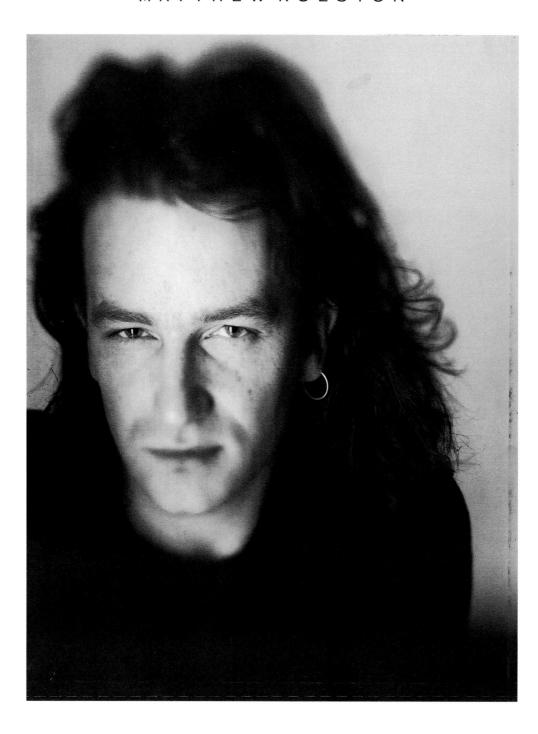

plate **32**

ART DIRECTOR *Fred Woodward*
PICTURE EDITOR *Laurie Kratochvil*
PUBLICATION *Rolling Stone*
PUBLISHER *Straight Arrow Publishers, Inc.*

U2's lead singer posed
for David Broskin's cover story "Bono—
In the Eighties Rock 'n'
Roll Went to Work for Corporations
and Got Up at 6:00 A.M."
November 1987.

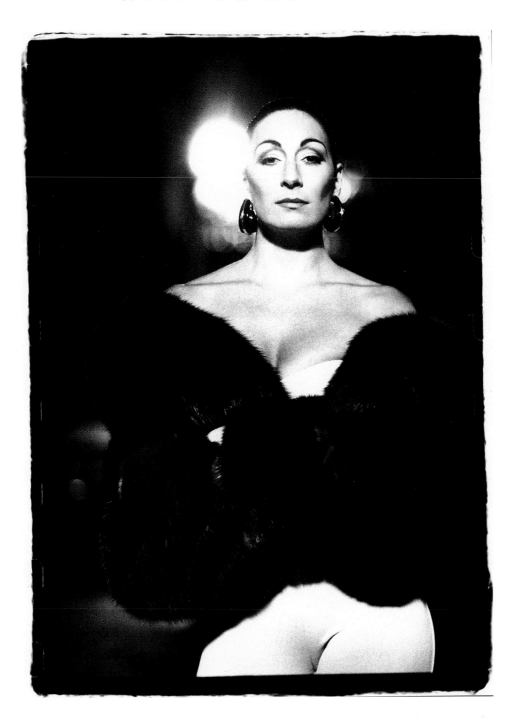

plate **33**

ART DIRECTOR *Wendall Harrington*
PICTURE EDITOR *Temple Smith*
PUBLICATION *Esquire*
PUBLISHER *Hearst Corporation*

Matthew Rolston's portraits
of the actress highlighted the article that asked,
"What is it about Anjelica Huston?"
September 1987.

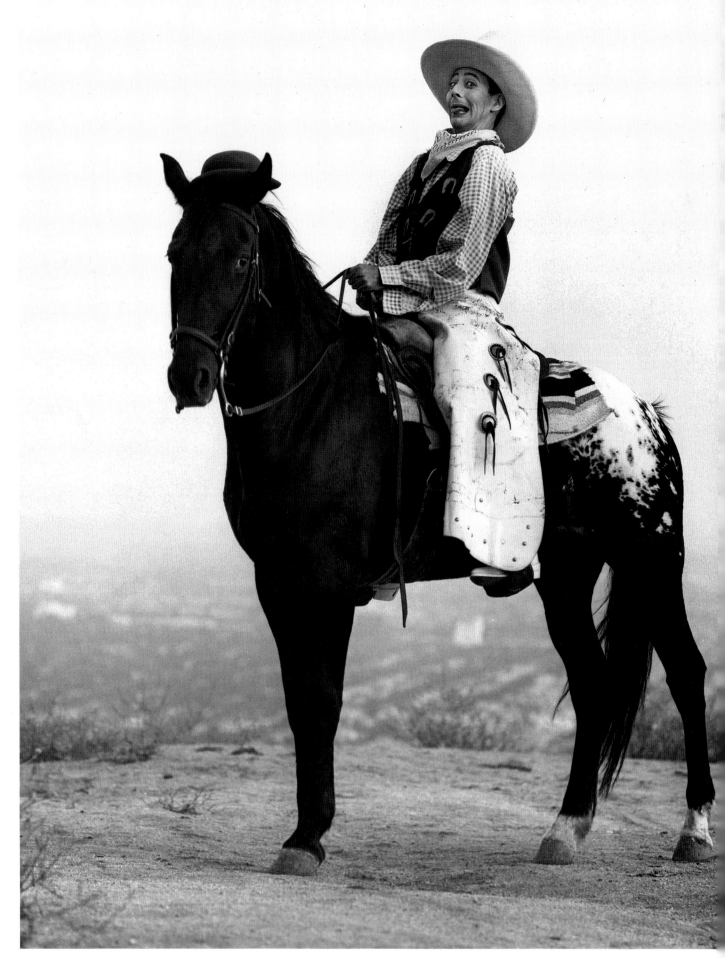

plate 34

ART DIRECTOR *Mark Balet*
PUBLICATION *Interview Magazine*
PUBLISHER *Andy Warhol Enterprises*

Pee-Wee Herman
is seen here on Mulholland Drive,
Los Angeles, from a
cover story featuring the comedian.
July 1987.

plate **35**

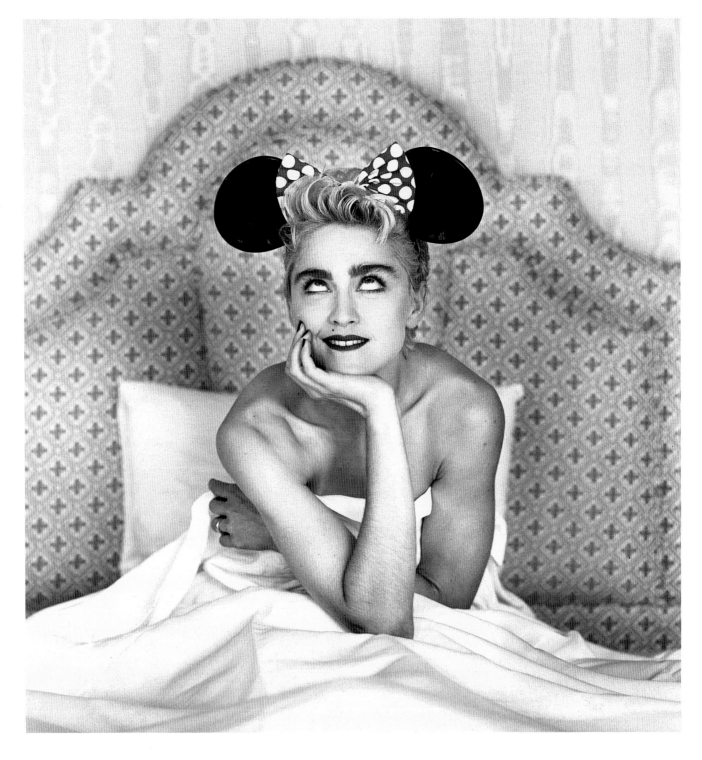

ART DIRECTOR *Fred Woodward*
PICTURE EDITOR *Laurie Kratochvil*
PUBLICATION *Rolling Stone*
PUBLISHER *Straight Arrow Publishers, Inc.*

*This shot of Madonna
was one of a series of photographs
in "Images 1967–1987,"
Rolling Stone's 20th anniversary issue.
September 1987.*

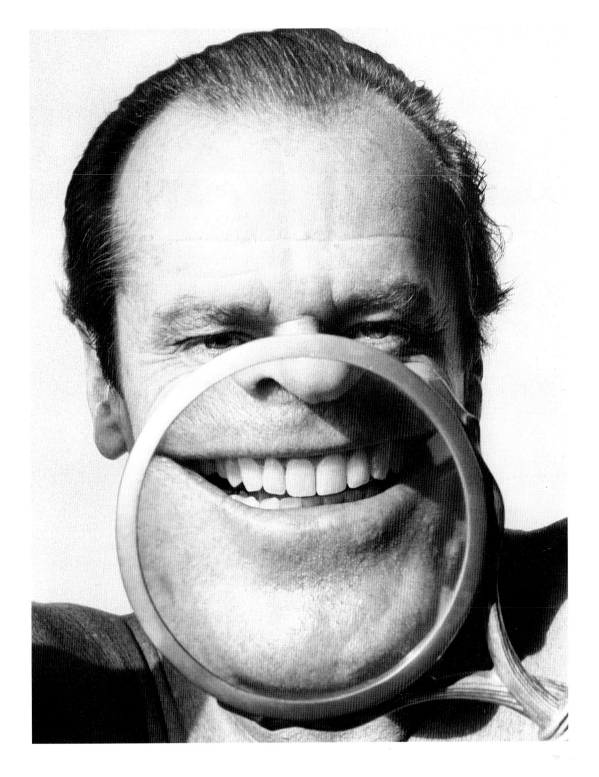

plate **36**

ART DIRECTOR *Fred Woodward*
PICTURE EDITOR *Laurie Kratochvil*
PUBLICATION *Rolling Stone*
PUBLISHER *Straight Arrow Publishers, Inc.*

*Herb Ritts captured
Jack Nicholson's grin for Lynn Hirschberg's
interview with the actor.
November 1987.*

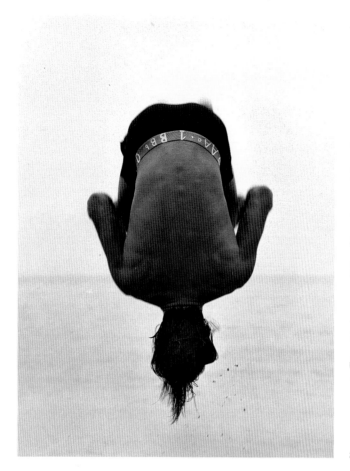

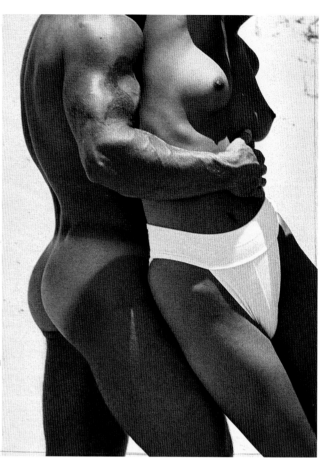

plate **37**

plate **38**

ART DIRECTOR *Herb Ritts*
PICTURE EDITOR *Michael Roberts*
PUBLICATION *Tatler*
PUBLISHER *Condé Nast Publications, Inc.*

*Herb Ritts's photograph
ran in a fashion spread featuring
swimwear. April 1987.*

ART DIRECTOR *Rip Georges*
PUBLICATION *L.A. Style*
PUBLISHER *L.A. Style, Inc.*

*"Beauty and the Beach,"
an underwear fashion story, featured these
photographs. February 1987.*

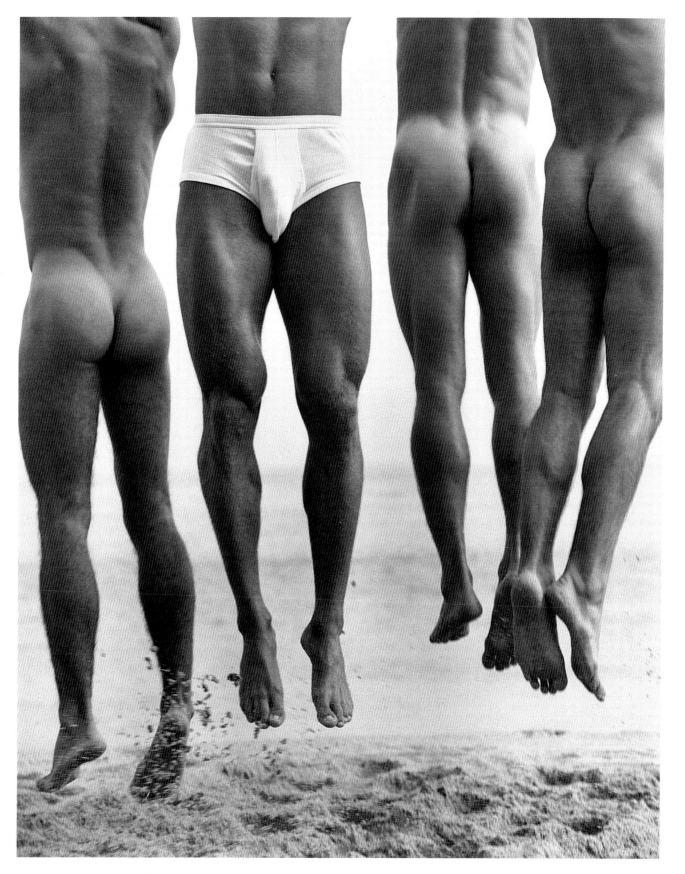

plate **39**

ART DIRECTOR *Lloyd Ziff*
PICTURE EDITOR *Kathleen Klech*
PUBLICATION *Condé Nast's Traveler*
PUBLISHER *Condé Nast Publications, Inc.*

*Helmut Newton's travel
feature "Berlin" offered an unusual look
at the city, including this
view of the discreet face of the restaurant
Das Exil. Also shown
here are Das Exil, interior, and the restaurant
Henne, renowned for its
fried chicken. October 1987.*

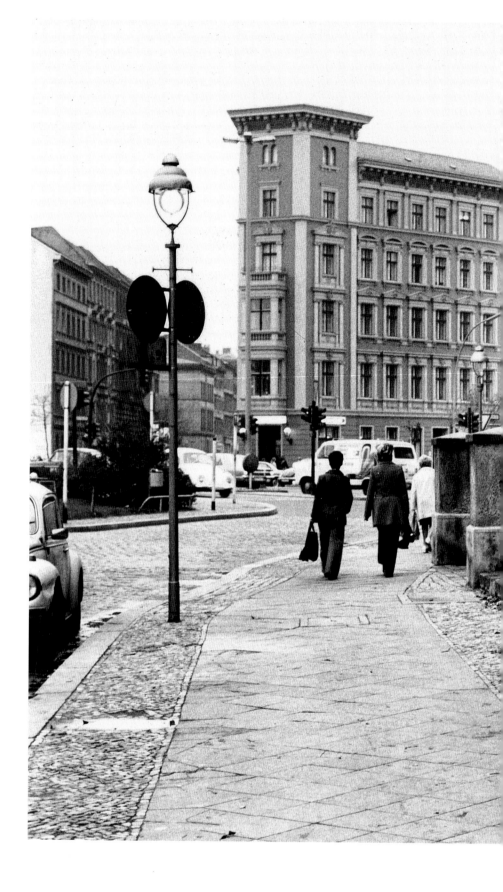

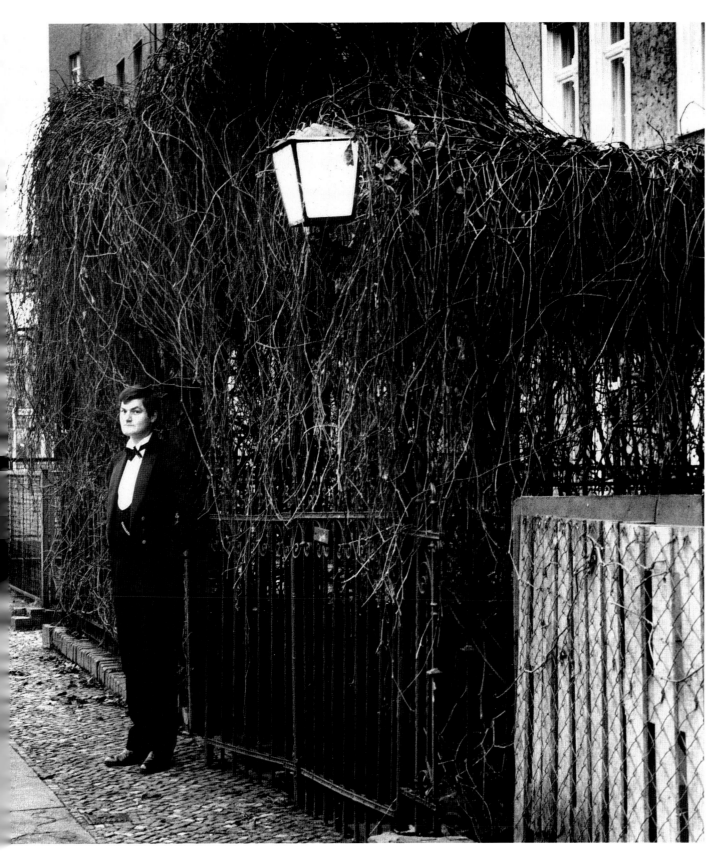

plate 40

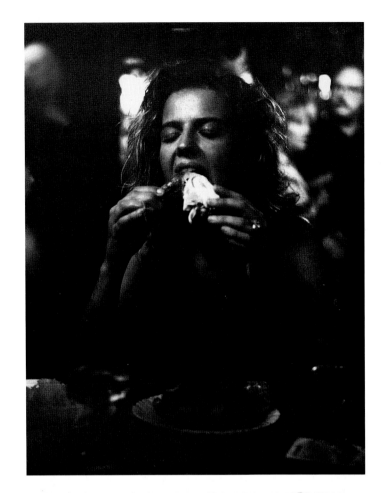

plate **41**

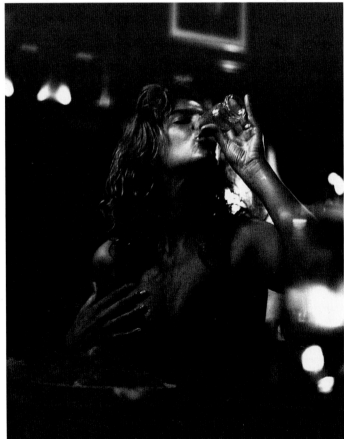

plate **42**

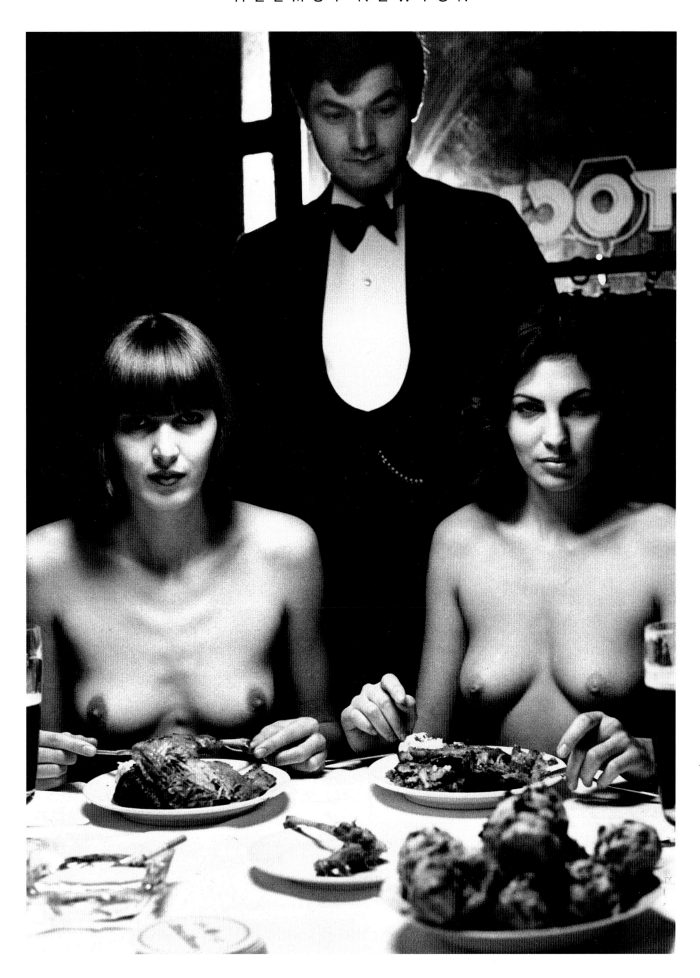

plate 43

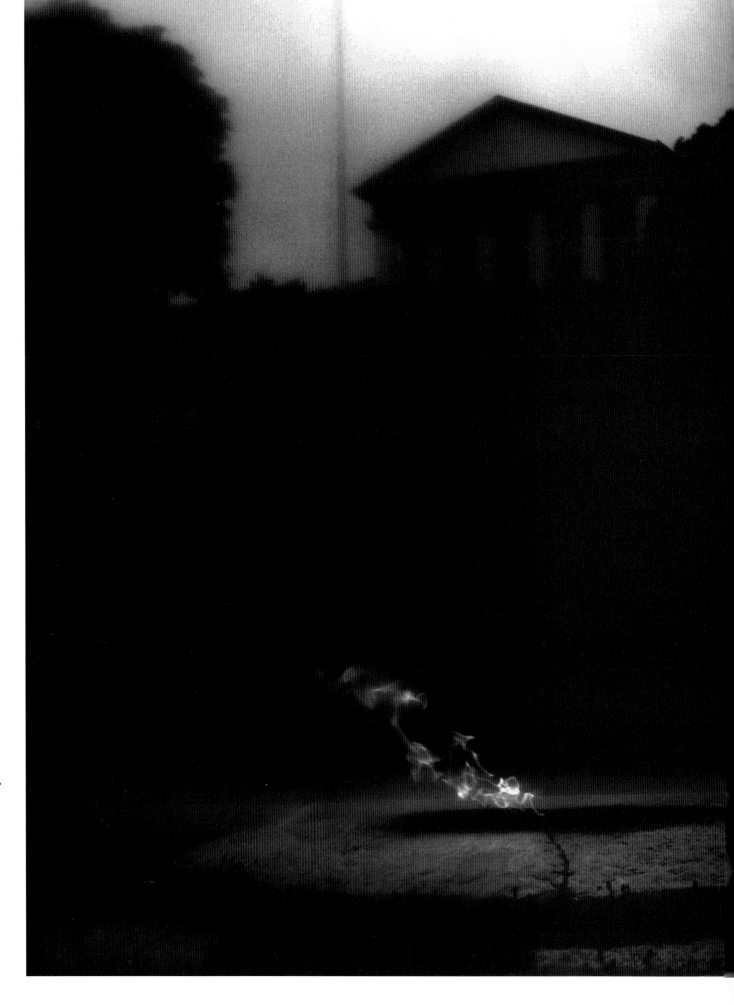

plate 44

ART DIRECTOR *Fred Woodward*
PUBLICATION *Regardie's Magazine*
PUBLISHER *Regardie's Magazine, Inc.*

John Kennedy's grave,
Arlington Cemetery, and the
Washington Monument
appeared in "Monuments of Stone,"
a pictorial series on
the memorials of Washington, D.C.
June 1987.

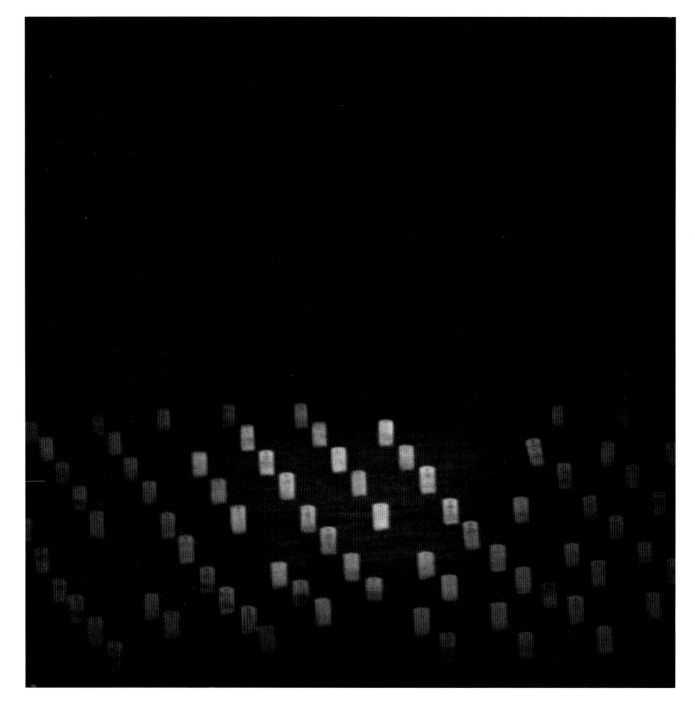

plate 45

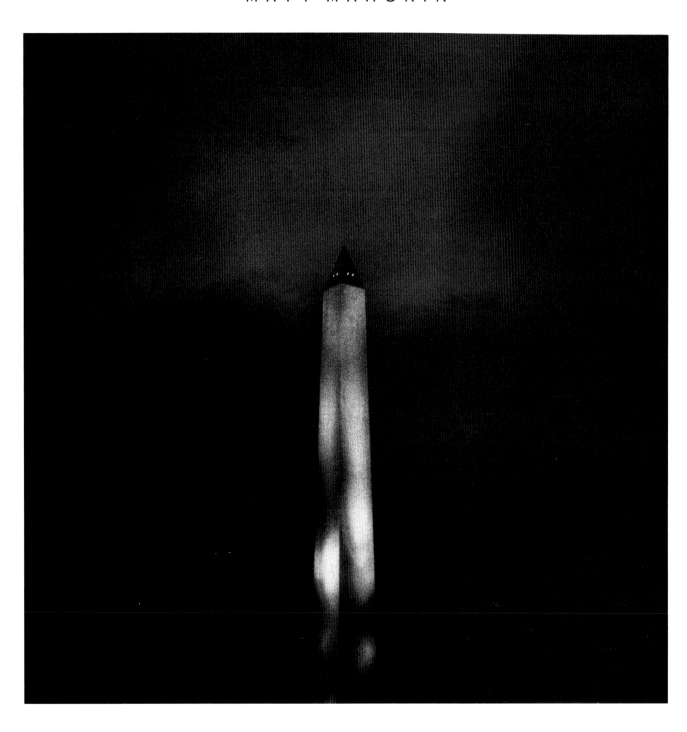

plate 46

ART DIRECTOR *Fabien Baron*
PUBLICATION *New York Woman*
PUBLISHER *American Express Publishing
Company*

*This is one of a series
of photographs taken at Bayview Prison,
New York, for Marilyn Johnson's article
"The Time of Their Lives."
May 1987.*

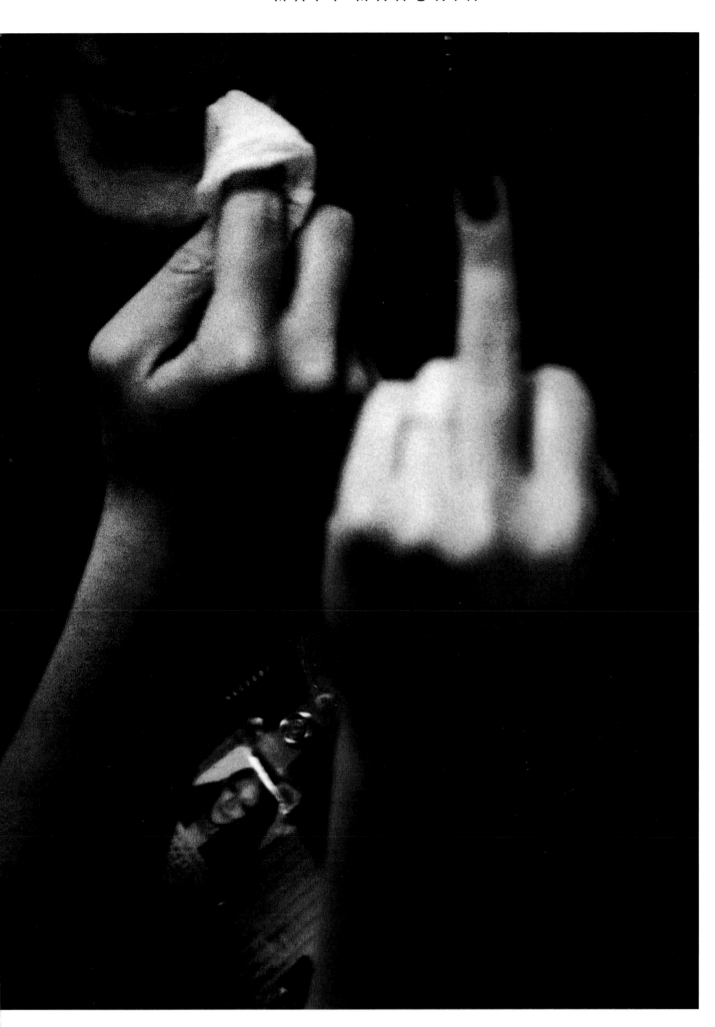

plate 47

plate **48**

ART DIRECTOR *Fred Woodward*
PICTURE EDITOR *Laurie Kratochvil*
PUBLICATION *Rolling Stone*
PUBLISHER *Straight Arrow Publishers, Inc.*

*James Hencke's interview
with John Fogerty featured this
portrait of the musician.
November 1987.*

ART DIRECTOR *Kerig Pope*
PUBLICATION *Playboy Magazine*
PUBLISHER *Playboy Enterprises, Inc.*

*Actor Dennis Quaid
poses for a* Playboy *interview.
November 1987.*

plate **49**

ART DIRECTOR *Fred Woodward*
PICTURE EDITOR *Laurie Kratochvil*
PUBLICATION *Rolling Stone*
PUBLISHER *Straight Arrow Publishers, Inc.*

*Matt Mahurin
photographed Robbie Robertson
for a Rolling Stone
interview with the musician.
November 1987.*

plate 50

plate **51**

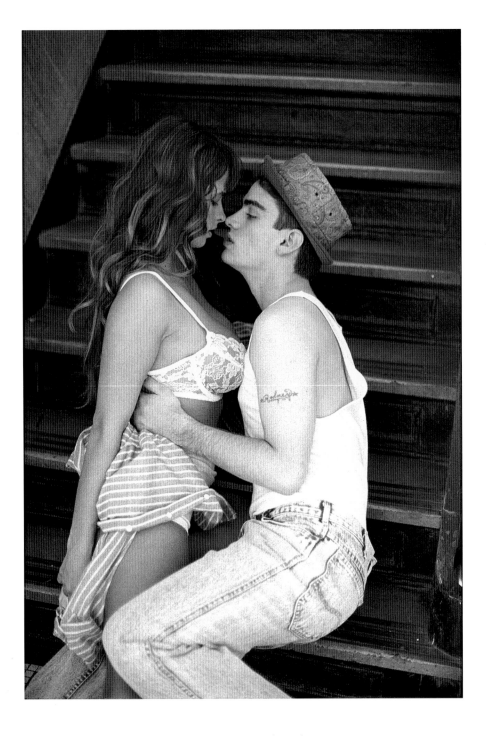

ART DIRECTOR *Derek Ungless*
PICTURE EDITOR *Laurie Schechter*
PUBLICATION *Rolling Stone*
PUBLISHER *Straight Arrow Publishers, Inc.*

*This four-part series
of photographs was featured in Laurie
Schechter's "A Love for
Real Not Fade Away." May 1987.*

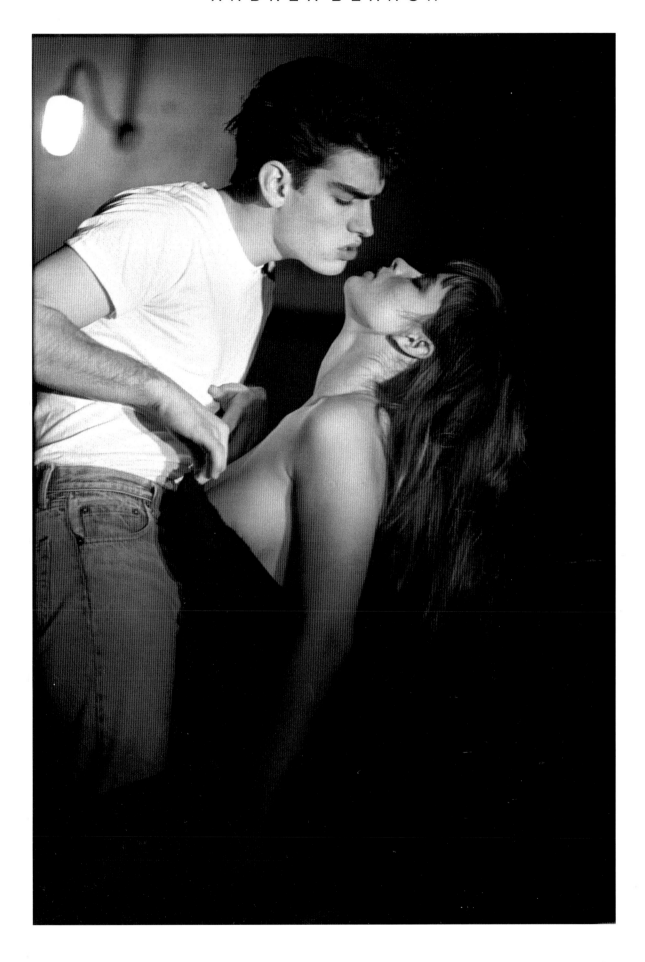

plate 52

plate **53**

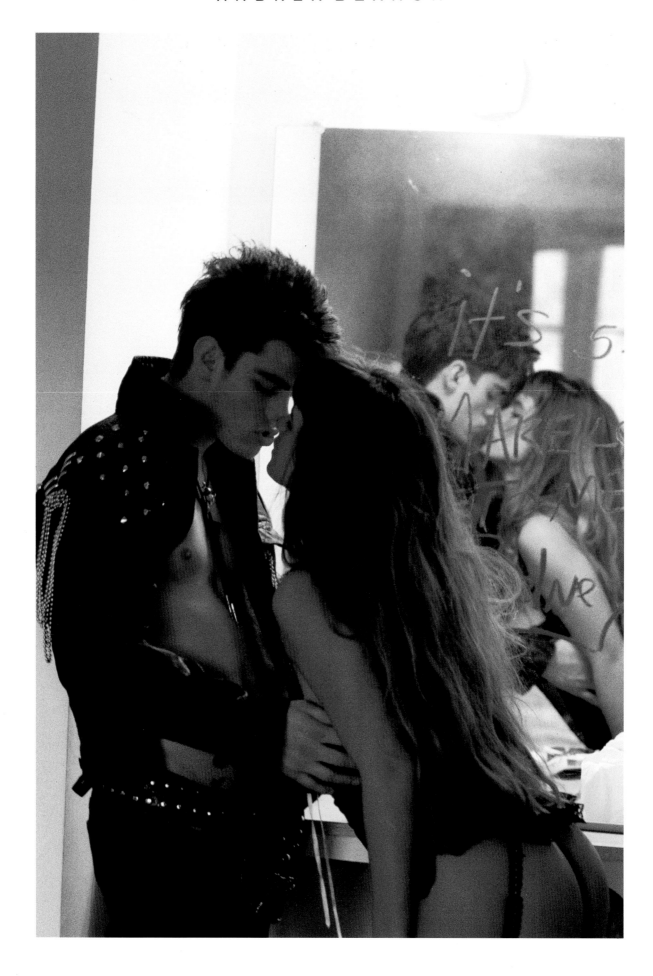

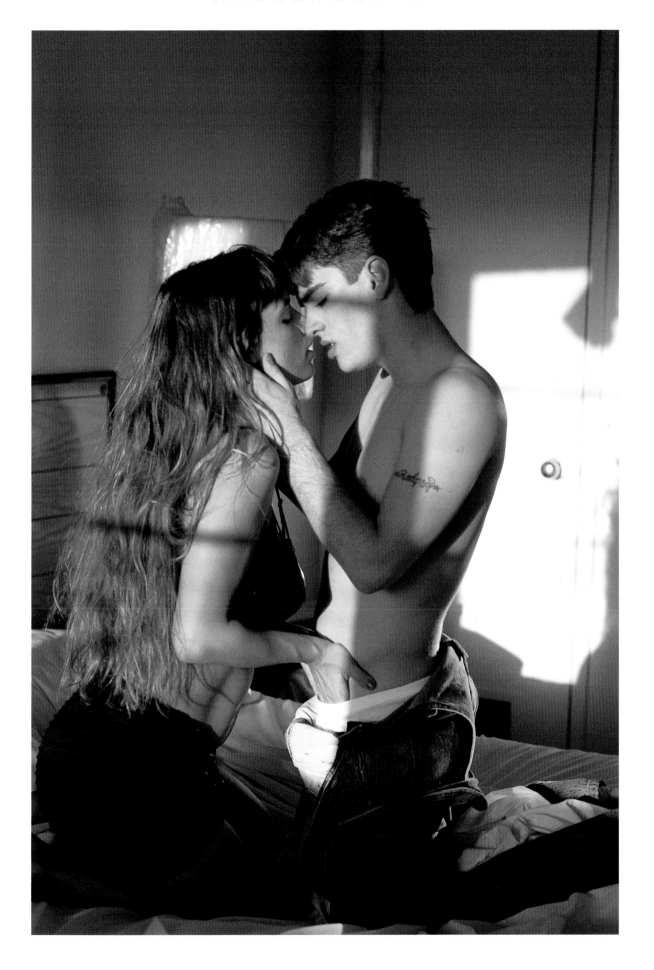

plate **54**

DENIS PIEL

plate 55

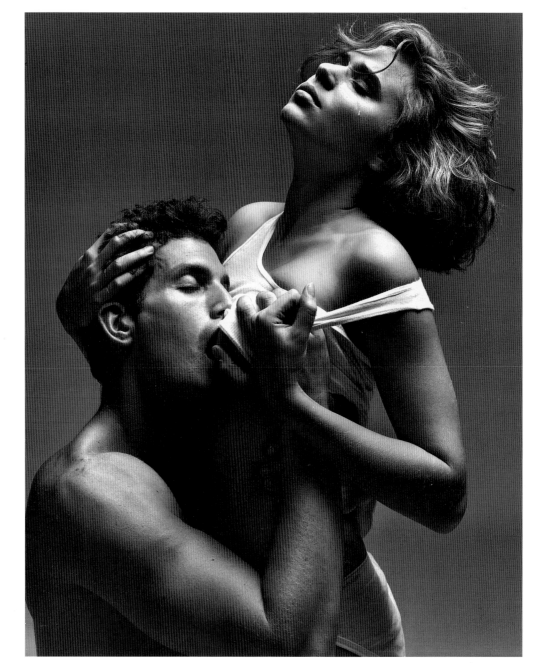

ART DIRECTOR *Mary Shanahan*
PICTURE EDITOR *Lisa Atkin*
PUBLICATION *Gentlemen's Quarterly*
PUBLISHER *Condé Nast Publications, Inc.*

*In the article
"What Women Want" a panel of eight
women discussed this
proverbial question. October 1987.*

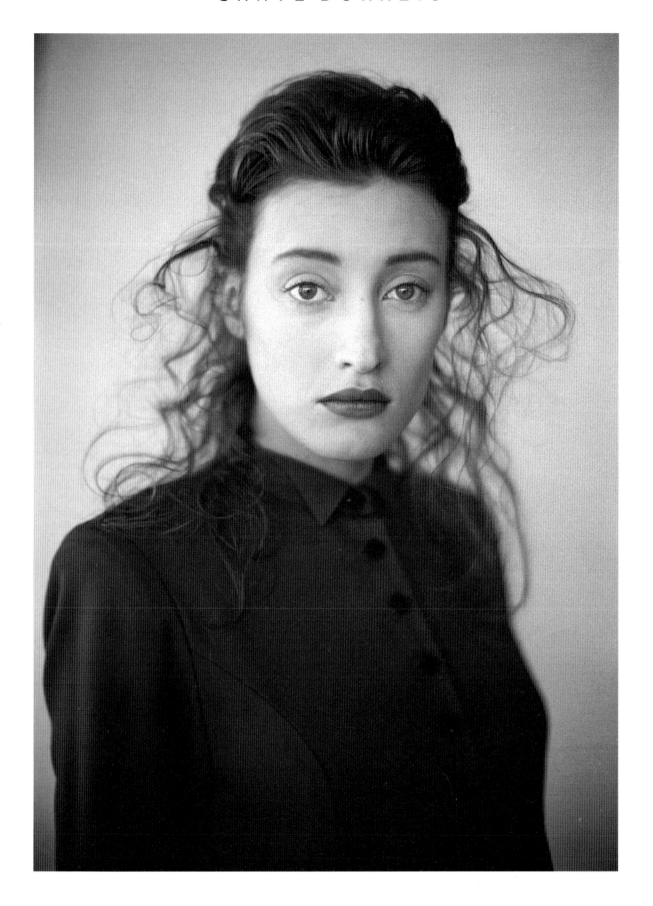

plate **56**

ART DIRECTOR *Rip Georges*
PUBLICATION *L.A. Style*
PUBLISHER *L.A. Style, Inc.*

L.A. Style *featured this cover*
photograph. April 1987.

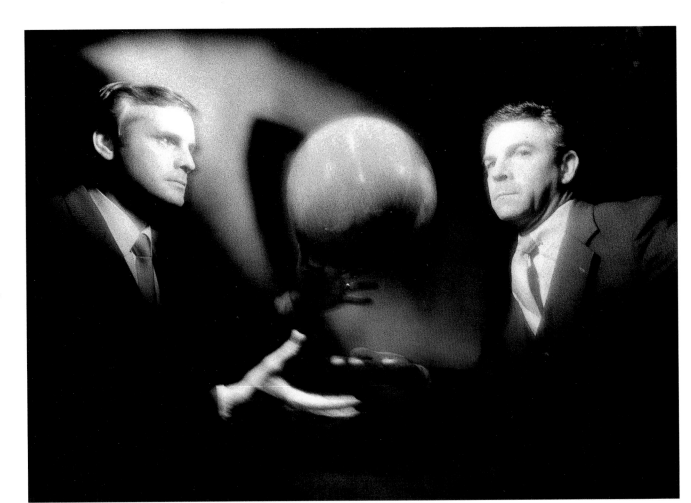

plate **57**

plate **58**

ART DIRECTOR *Wendall Harrington*
PICTURE EDITOR *Lucy Handley*
PUBLICATION *Esquire*
PUBLISHER *Hearst Corporation*

*"Nuke City," a nonfiction
story by Martin Amis, featured these
photographs. October 1987.*

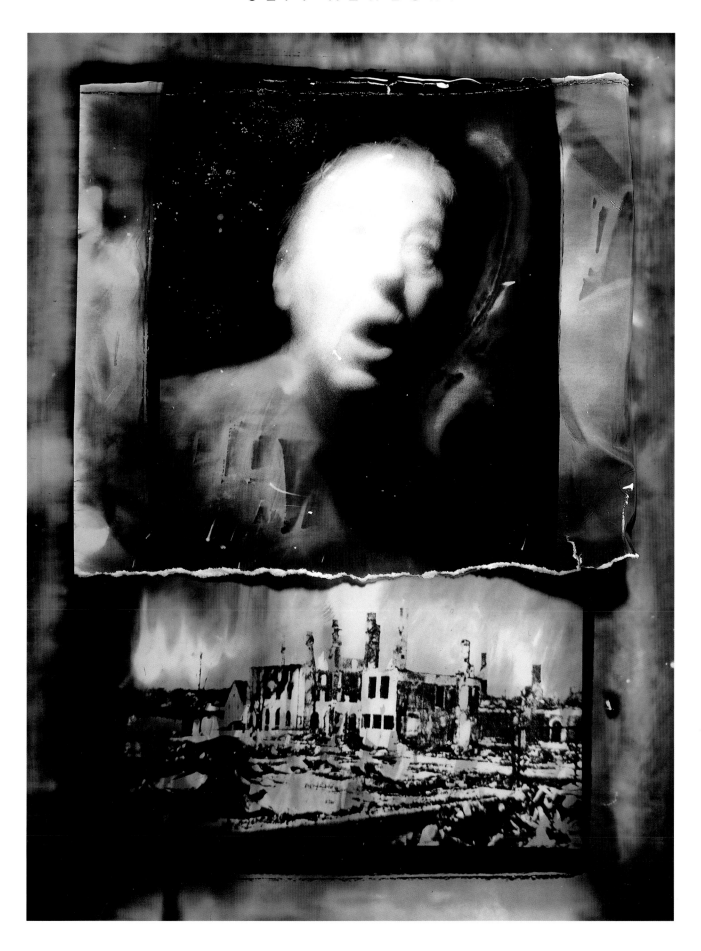

plate 59

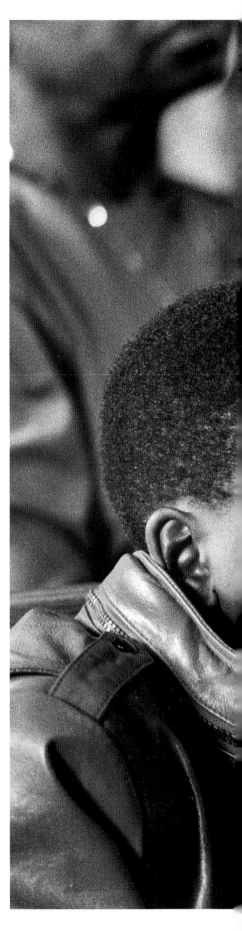

PICTURE EDITOR *P. K. Weis*
PUBLICATION *Tucson Citizen*
PUBLISHER *Citizen Publishing Company*

The Arizona newspaper
story "Remembering the Dream"
covered a local ceremony
honoring Martin Luther King, Jr. January 1987.

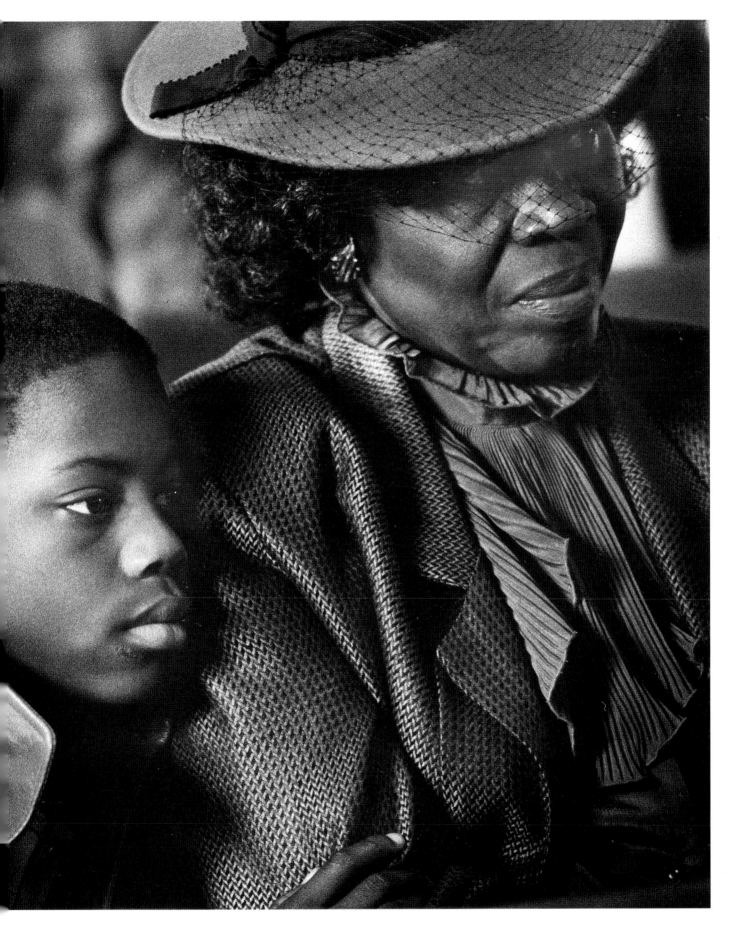

plate 60

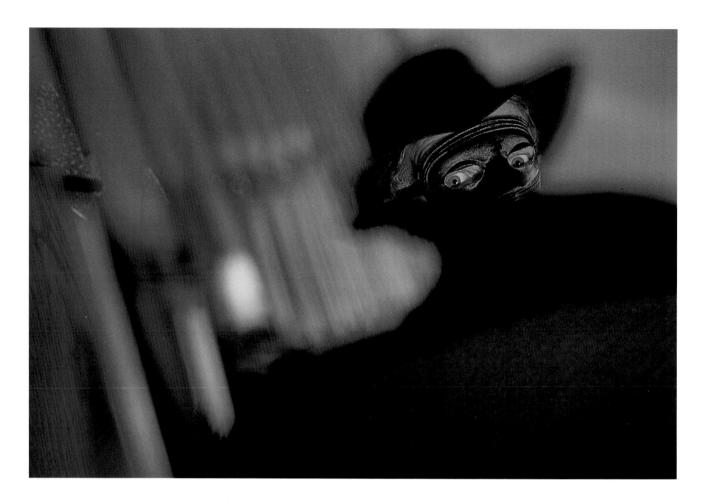

plate **61**

ART DIRECTOR *Fred Woodward*
PUBLICATION *Texas Monthly*
PUBLISHER *Texas Monthly, Inc.*

*When an elaborate new pipe
organ was installed at the University
of Texas, Steven Pumphrey
created this Phantom-of-the-Opera
image to accompany the
announcement. October 1986.*

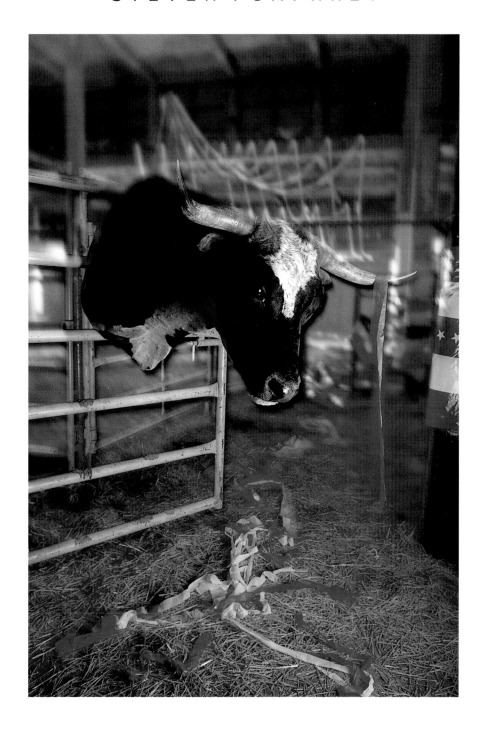

plate 62

ART DIRECTOR *Fred Woodward*
PUBLICATION *Texas Monthly*
PUBLISHER *Texas Monthly, Inc.*

*The infamous Longhorn
bull christened "Texas U.S.A." because
of the state pattern on his
forehead is seen here in a posthumous
portrait from "The
Bum Steer Awards." January 1987.*

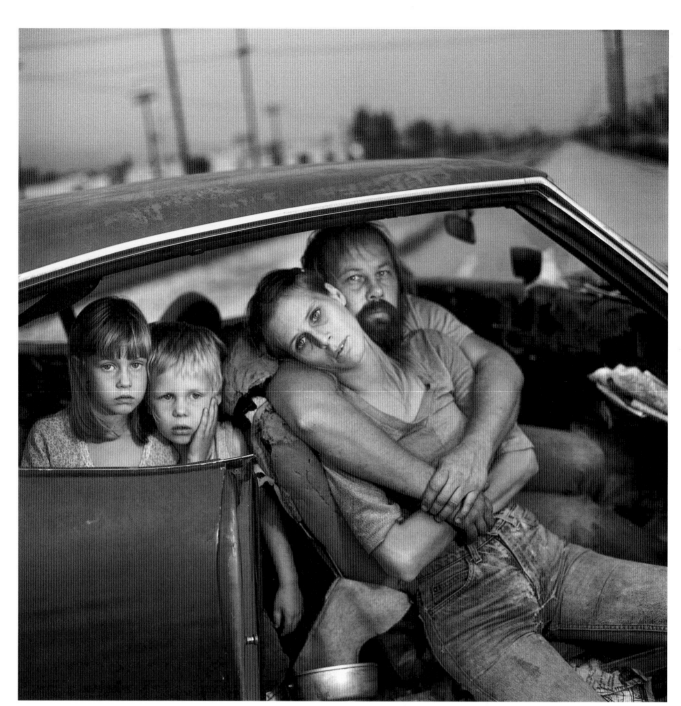

plate **63**

ART DIRECTOR *Peter Howe*
PICTURE EDITOR *Peter Howe*
PUBLICATION *Life Magazine*
PUBLISHER *Time, Inc.*

*"A Week in the Life of
a Homeless Family," by Anne Fadiman,
offered this look at the
Damm family, Los Angeles.
December 1987.*

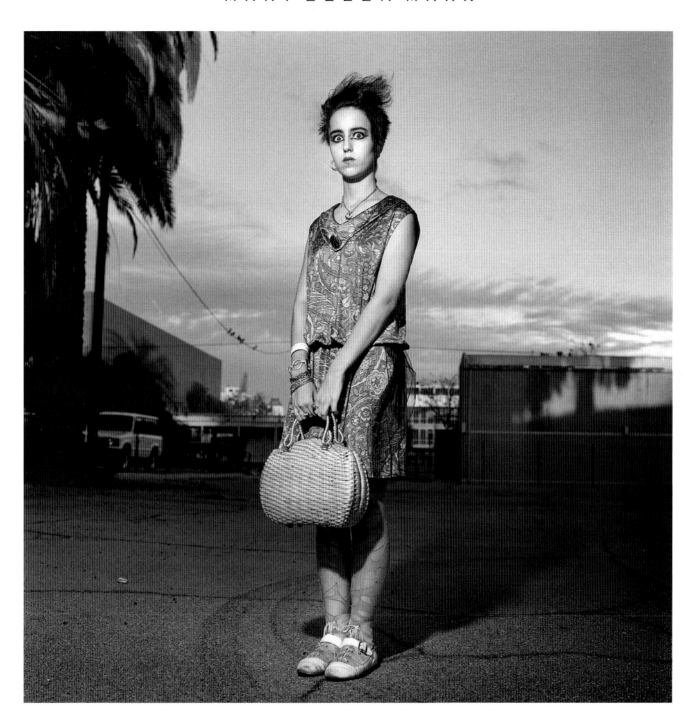

plate **64**

EXECUTIVE PRODUCER *Michael Evans*
PUBLICATION *Homeless in America:*
A Photographic Project,
October 1987

The plight of the
homeless in America is dramatically
documented in a series of
photographs for an exhibition and
catalog. This shot
shows a runaway teenager on
Hollywood Boulevard.

plate 65

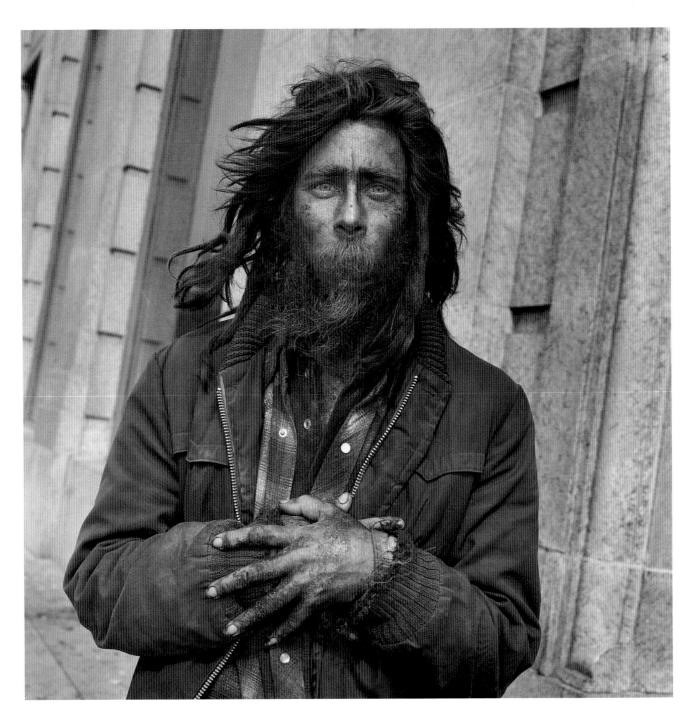

Bob, from Ohio.

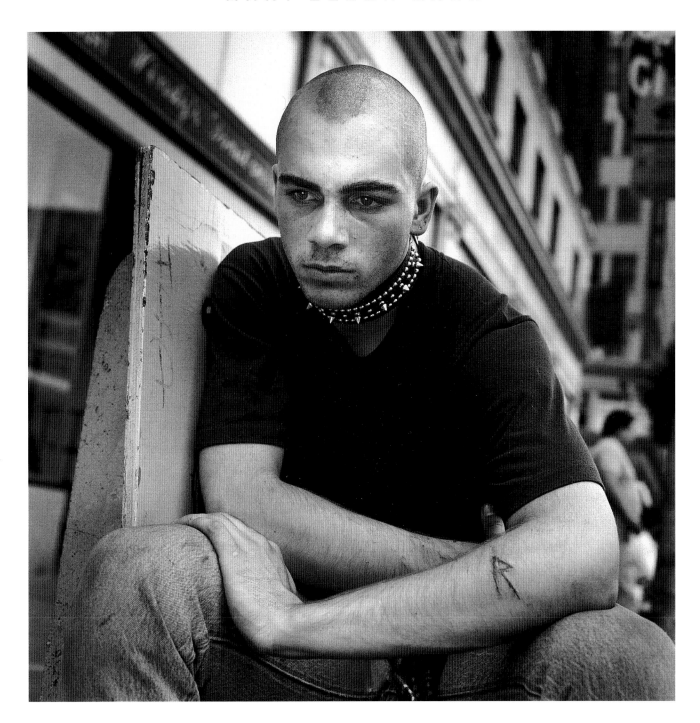

plate **66**

David, a runaway from the East Coast.

plate 67

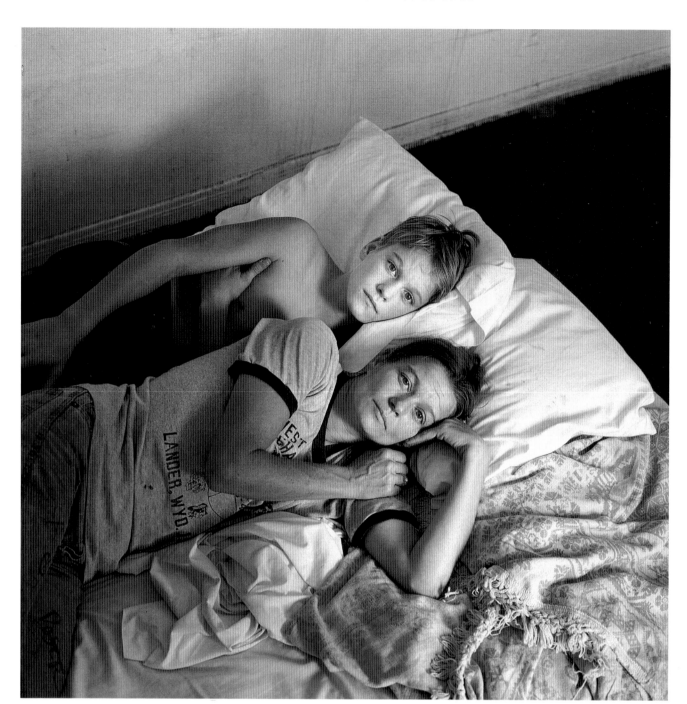

Mother and son
at the Gilbert Hotel, Hollywood.

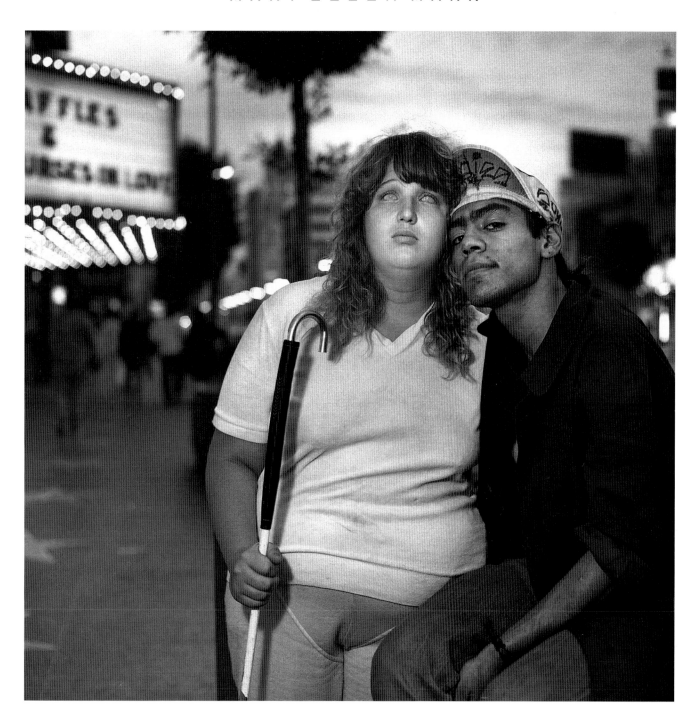

plate **68**

Shadow, with her friend Sonny.

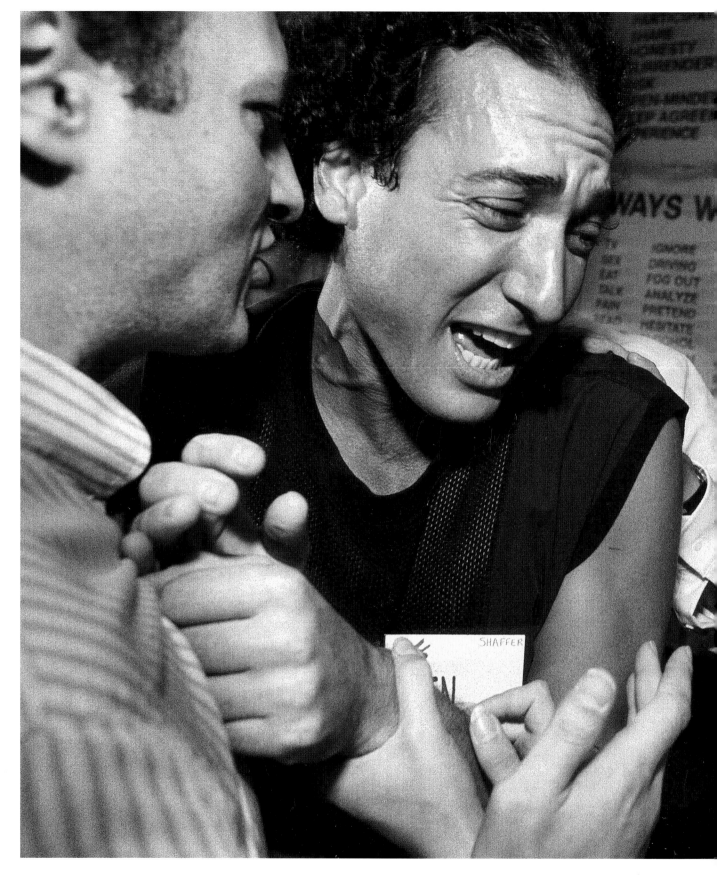

plate **69**

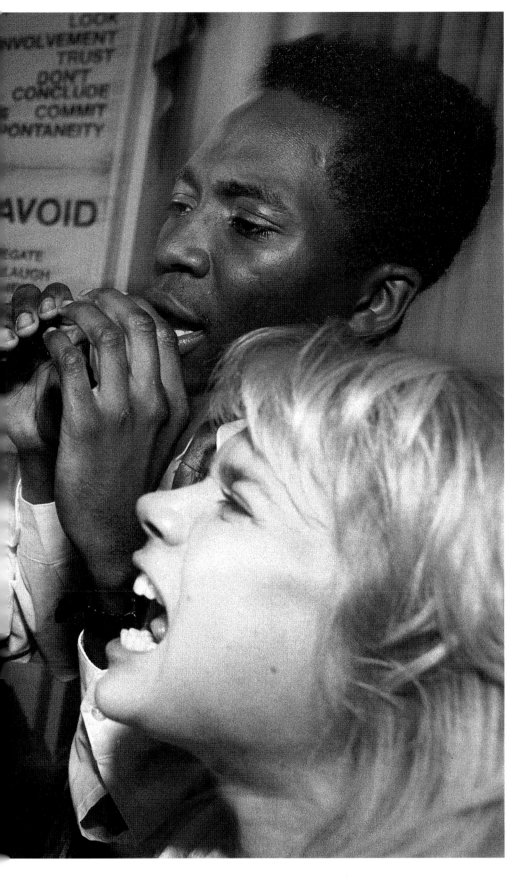

ART DIRECTOR *Brian Noyes*
PICTURE EDITOR *Molly Roberts*
PUBLICATION *Washington Post Magazine*
PUBLISHER *Washington Post Company*

An emotional moment
at a training session of Lifespring, a
self-improvement organization,
is captured for Marc Fisher's article
"I Cried Enough to Fill a Glass."
October 1987.

plate 70

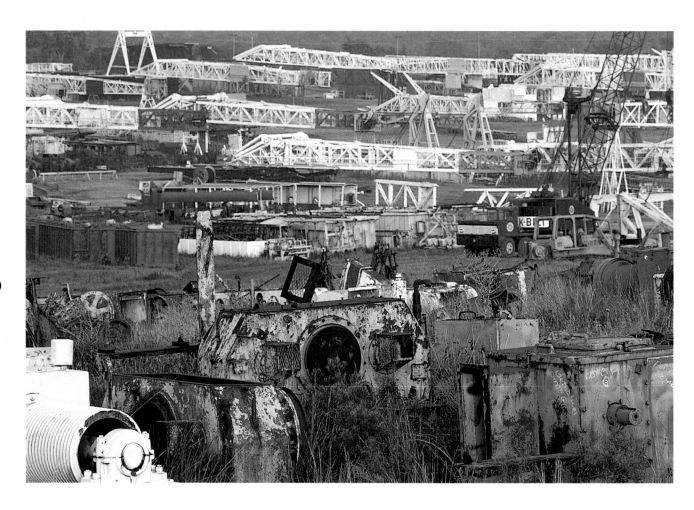

PICTURE EDITOR *Maureen Benziger*
PUBLICATION *Fortune Magazine*
PUBLISHER *Time, Inc.*

*The slowdown in oil
drilling and exploration is
demonstrated in
this photograph of idle
equipment that
accompanied a news story.
August 1987.*

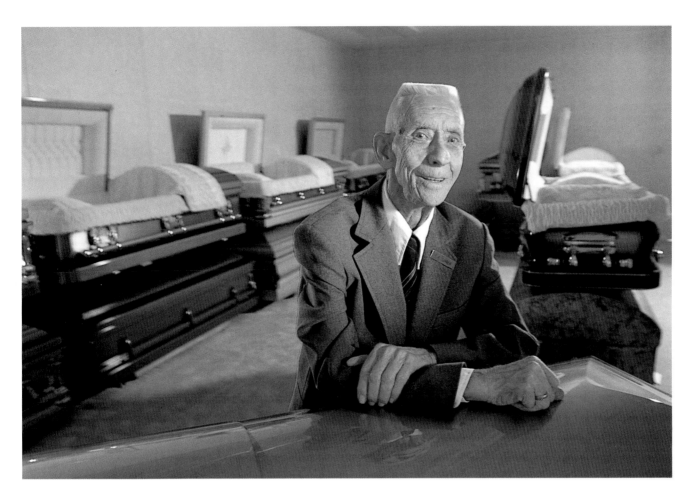

plate 71

ART DIRECTOR *D. J. Stout*
PICTURE EDITOR *Nancy E. McMillen*
PUBLICATION *Texas Monthly*
PUBLISHER *Texas Monthly, Inc.*

Bert Turner, doorman
at the Colonial Funeral Home
in Brady, Texas,
is portrayed for the article
"Just This Side of
Heaven," by Arnie Weissman.
November 1987.

plate 72

ART DIRECTOR *Wendall Harrington*
PICTURE EDITOR *Temple Smith*
PUBLICATION *Esquire*
PUBLISHER *Hearst Corporation*

*The editorial sequence
"The Passions of Men, 1987" captured
the different characteristics
of several well-known men, including
Mike Wallace and Des
McAnuff, Artistic Director of the La
Jolla Playhouse. June 1987.*

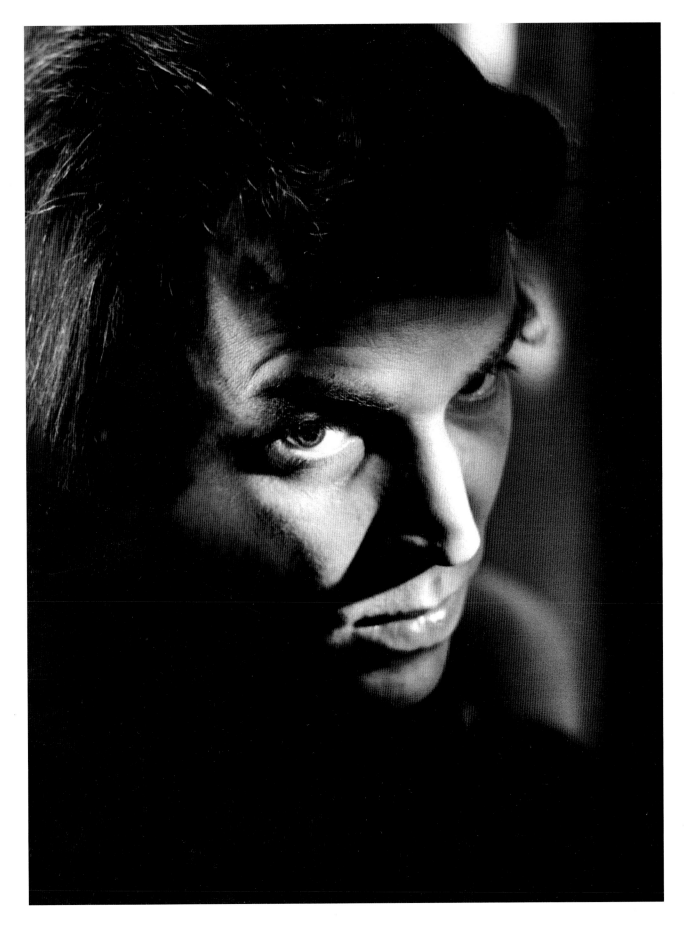

plate **73**

plate **74**

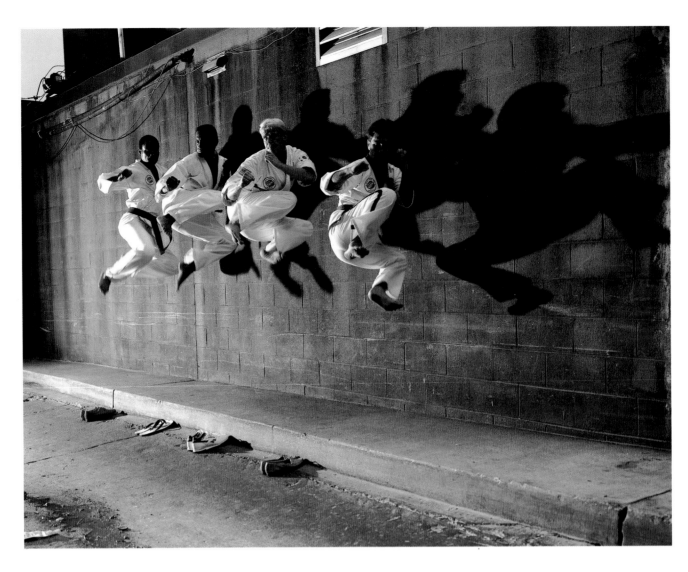

ART DIRECTOR *Brian Noyes*
PICTURE EDITOR *Molly Roberts*
PUBLICATION *Washington Post Magazine*
PUBLISHER *Washington Post Company*

*Tae Kwon Do instructors
were photographed outside the Jhoon Rhee
studio in Georgetown for
the weekly feature "Washington Groups."
September 1987.*

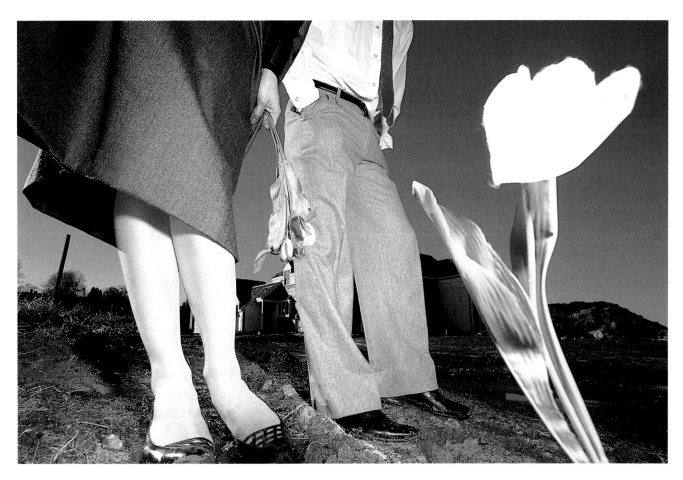

plate 75

ART DIRECTOR *Wendall Harrington*
PICTURE EDITOR *Temple Smith*
PUBLICATION *Esquire*
PUBLISHER *Hearst Corporation*

*This image is an
illustration for Nora Ephron's short story
"Landscape." April 1987.*

plate **76**

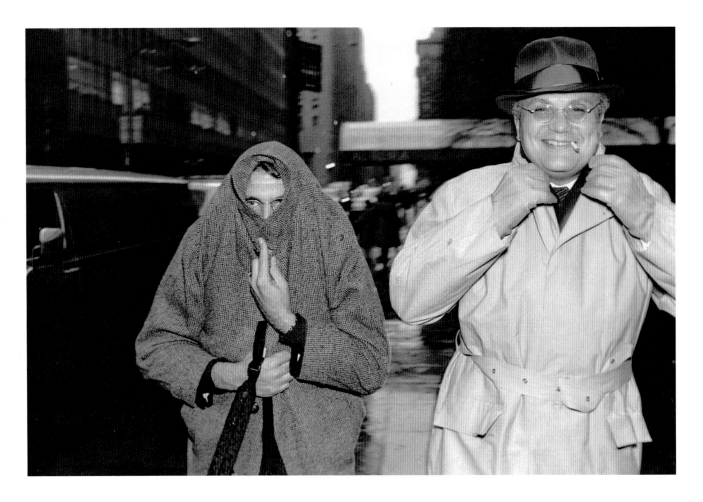

ART DIRECTOR *Nancy Butkus*
PUBLICATION *Manhattan, Inc.*
PUBLISHER *Manhattan Magazine, Inc.*

For the article "Monsieur X,"
by Carol Squiers, Chris Callis photographed
Xavier Moreau (Wayne
Maser appears inside the coat).
February 1987.

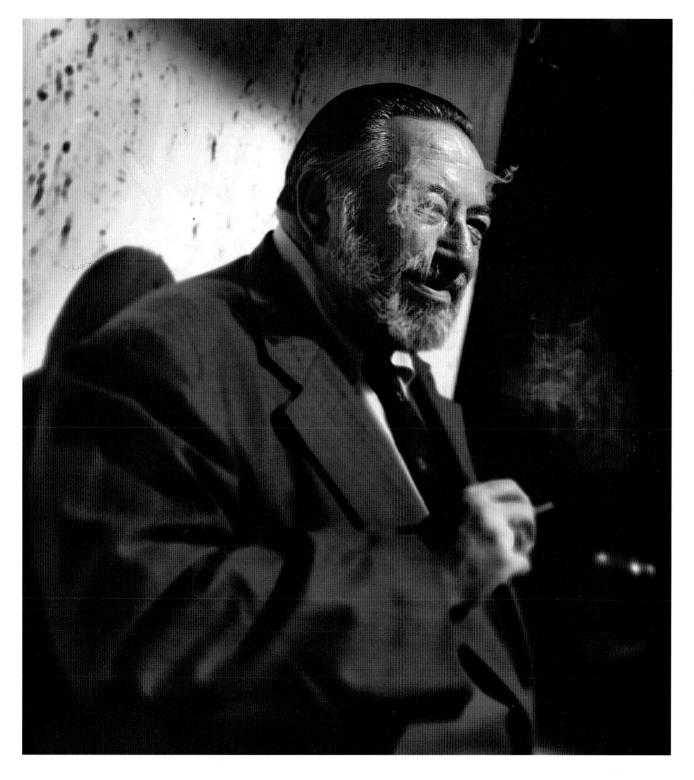

plate **77**

ART DIRECTOR *Fred Woodward*
PUBLICATION *Regardie's Magazine*
PUBLISHER *Regardie's Magazine, Inc.*

*Joe Nellis is portrayed
in his article "On the Trail of Bugsy,
Blackie and Lucky." July 1987.*

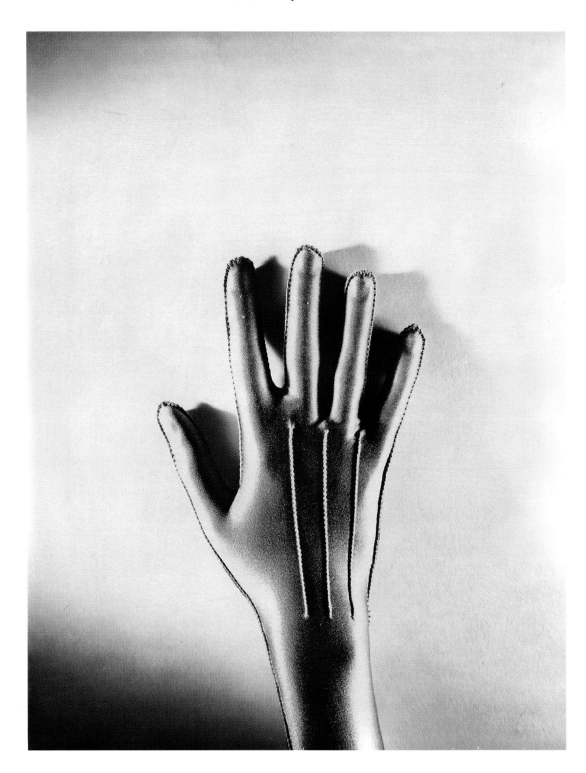

plate **78**

ART DIRECTOR *Fabien Baron*
PUBLICATION *New York Woman*
PUBLISHER *American Express Publishing Company*

A fashion photo essay,
"The Soul of Design," was inspired by
the work of several
well-known designers, such as this lycra glove
by Jean-Paul Gaultier.

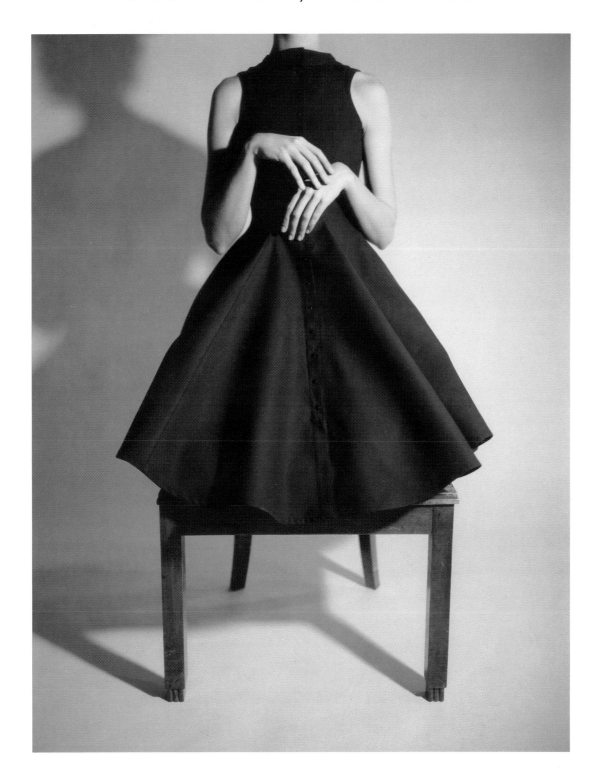

plate 79

Also shown are satin dress by Thierry Mugler,
silk shirt by Martine Sitbon,
plaid skirt by Comme des Garçons,
silk scarf by Hermès,
polo shirt by Azzedine Alaia, cotton
dress by Yohji Yamamoto,
and black-and-white make-up by Lancôme.
April 1987.

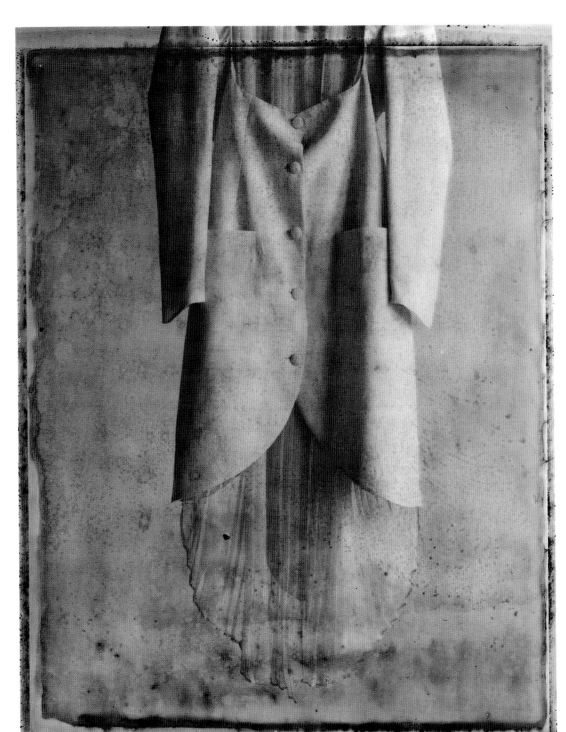

plate 80

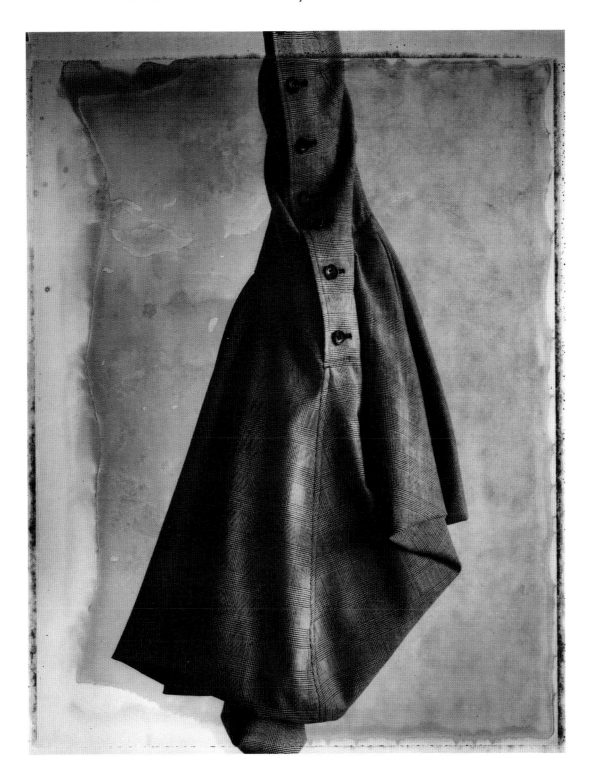

plate **81**

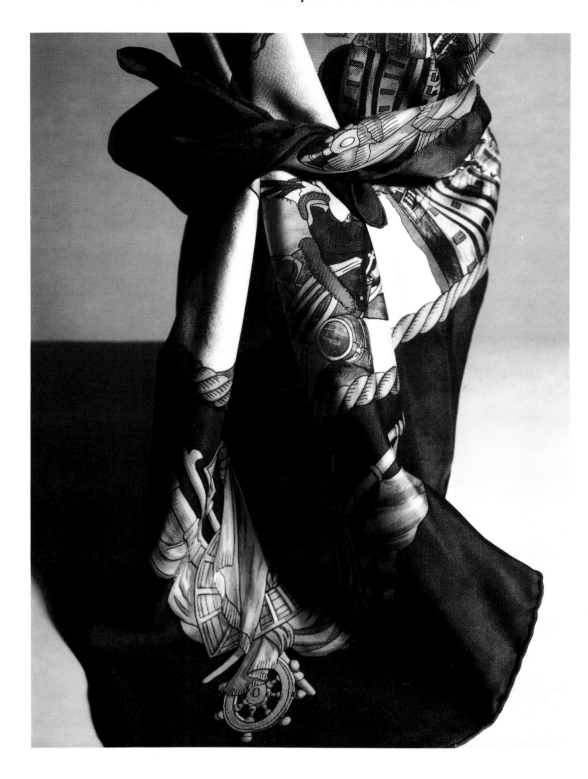

plate 82

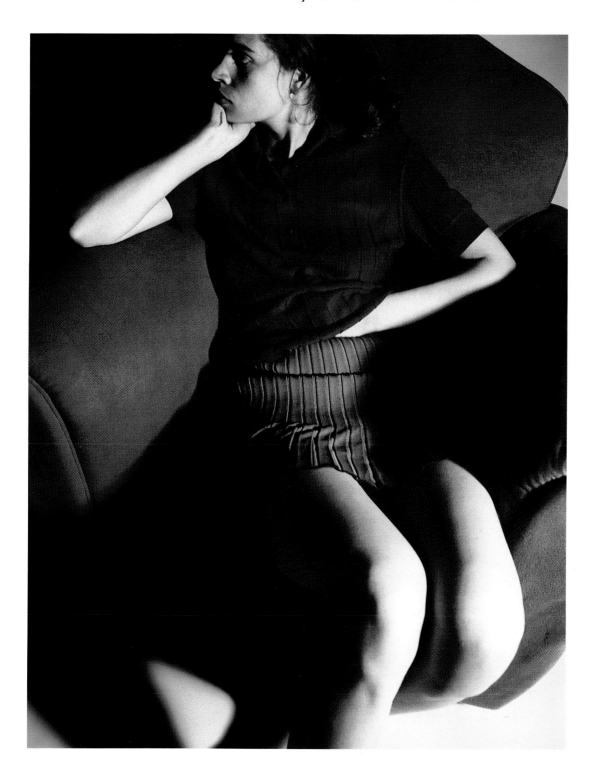

plate **83**

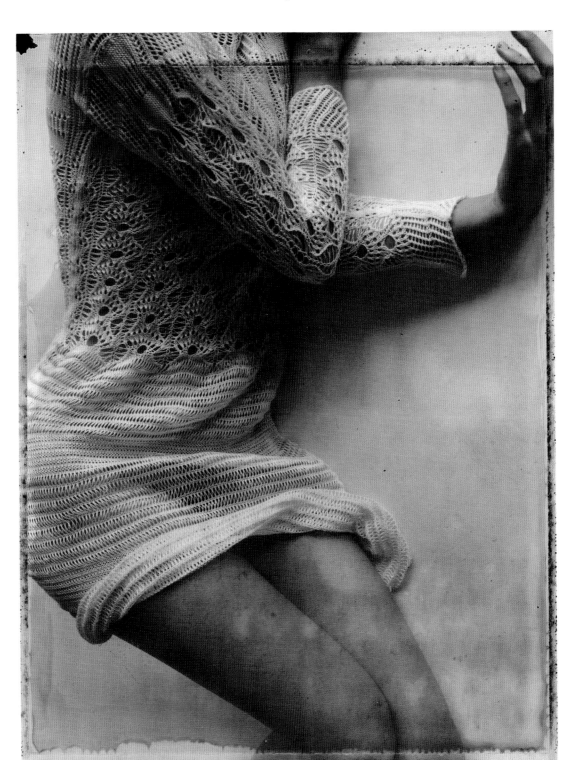

plate **84**

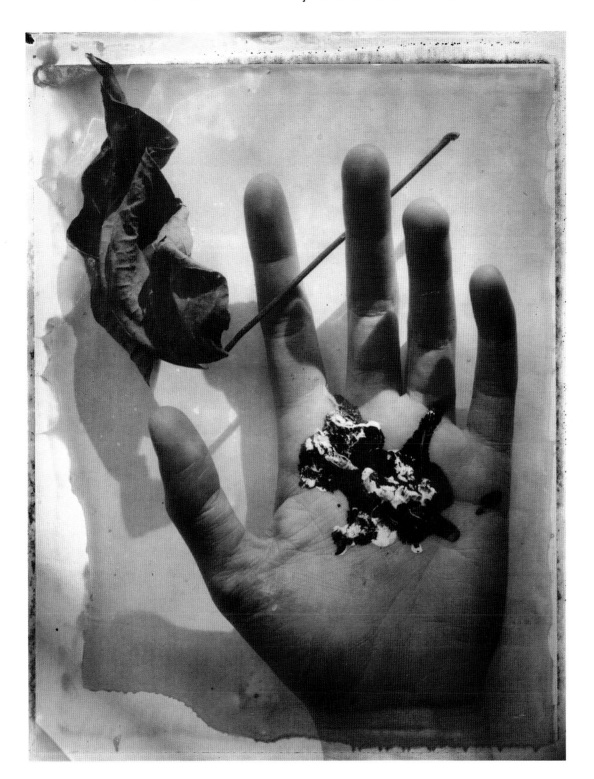

plate 85

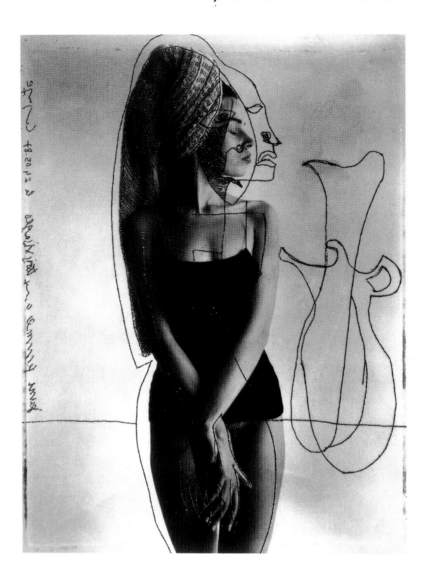

plate **86**

ART DIRECTOR *Fabien Baron*
PUBLICATION *New York Woman*
PUBLISHER *American Express Publishing
Company*

*To introduce Calvin Klein's
fall line, Jean-François Lepage produced
the fashion photo essay
"With a Soft Touch." September 1987.*

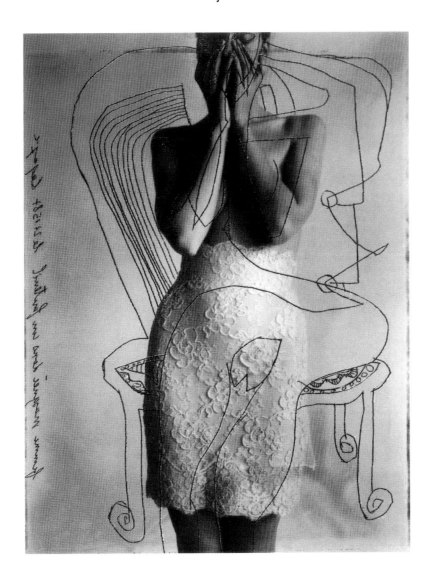

plate **87**

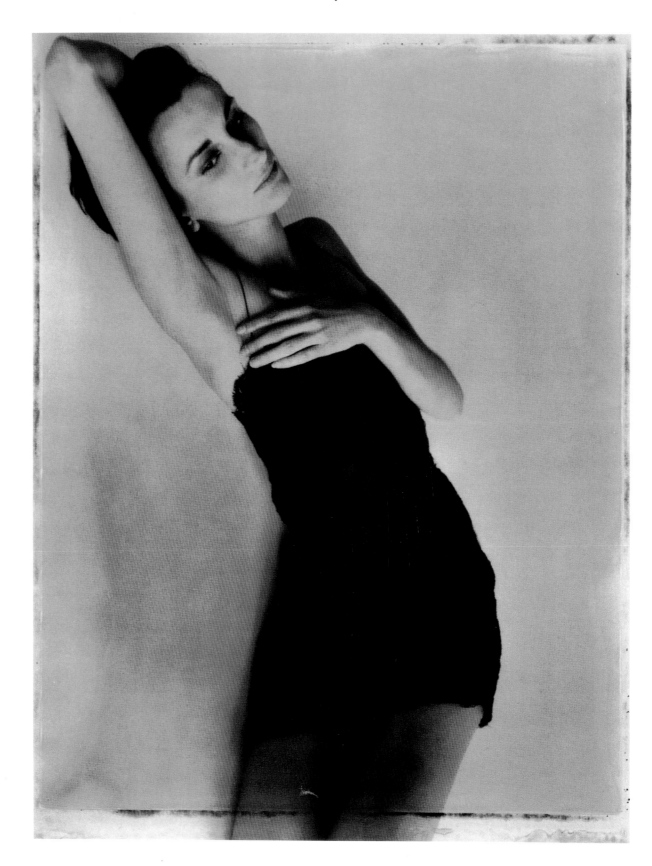

plate **88**

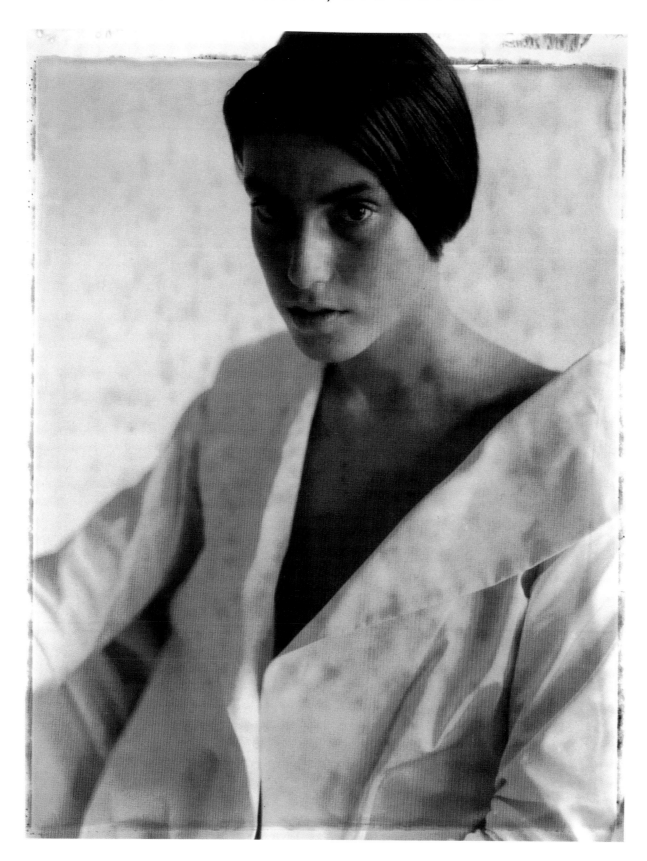

plate **89**

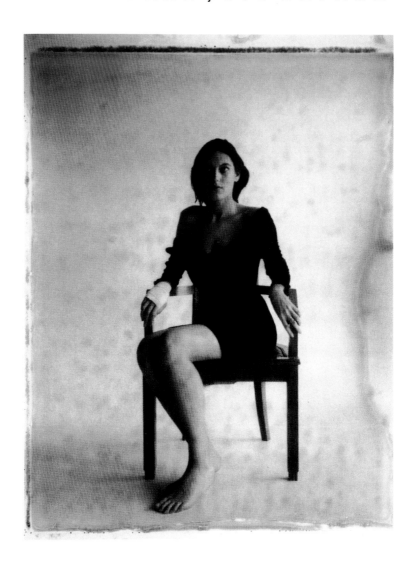

plate 90

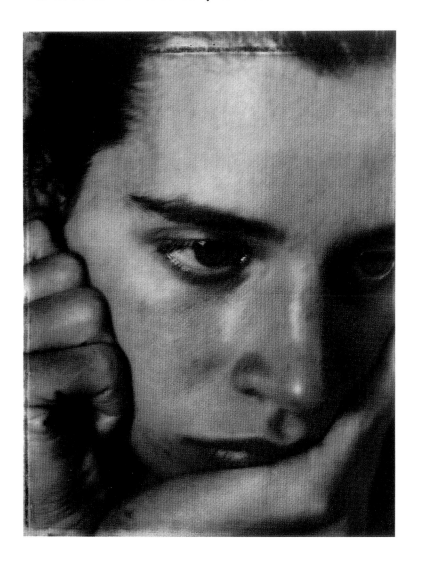

plate **91**

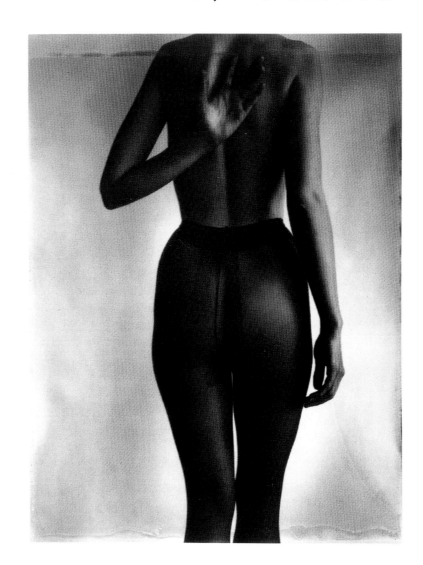

plate **92**

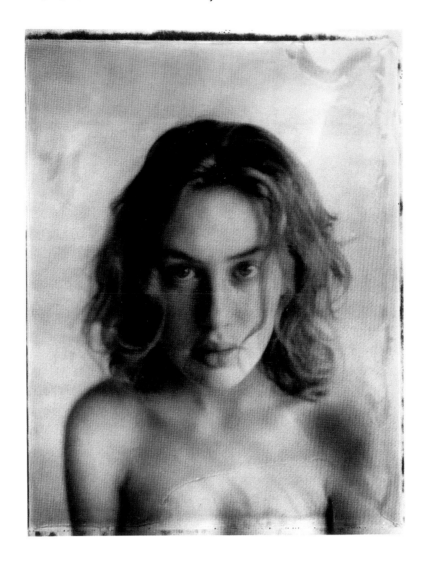

plate **93**

plate **94**

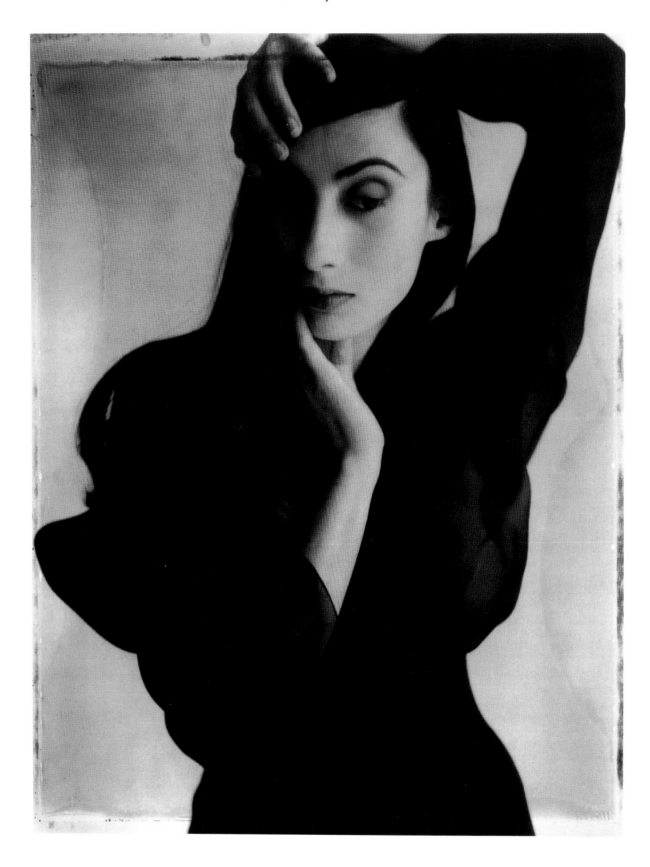

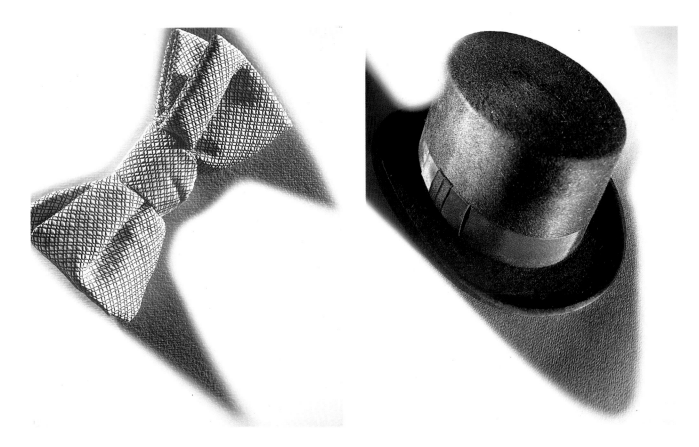

plate **95**

plate **96**

PICTURE EDITOR *Temple Smith*
PUBLICATION *Esquire*
PUBLISHER *Hearst Corporation*

*Raymond Meier's fashion
still lifes accompanied the article "Tux Redux."
December 1987.*

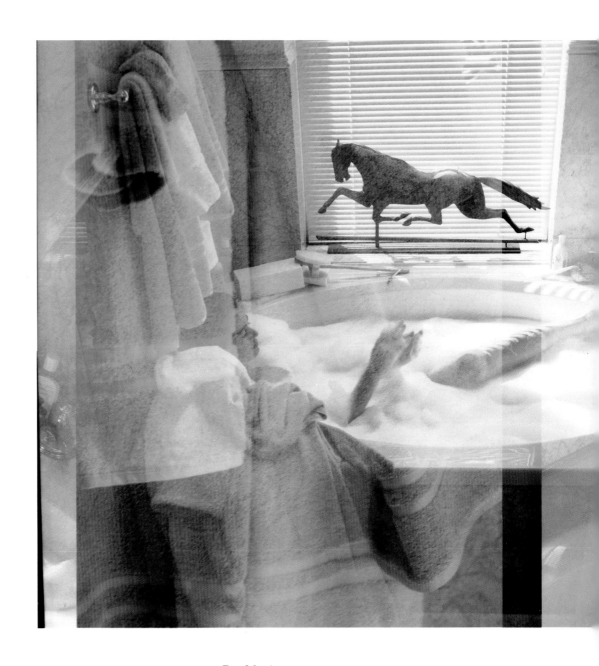

ART DIRECTOR *Don Morris*
PICTURE EDITOR *William Nabers*
PUBLICATION *Metropolitan Home*
PUBLISHER *Meredith*

Ziva Freiman's article
"Rituals" illustrated the practical and
emotional function of
gift products. December 1987.

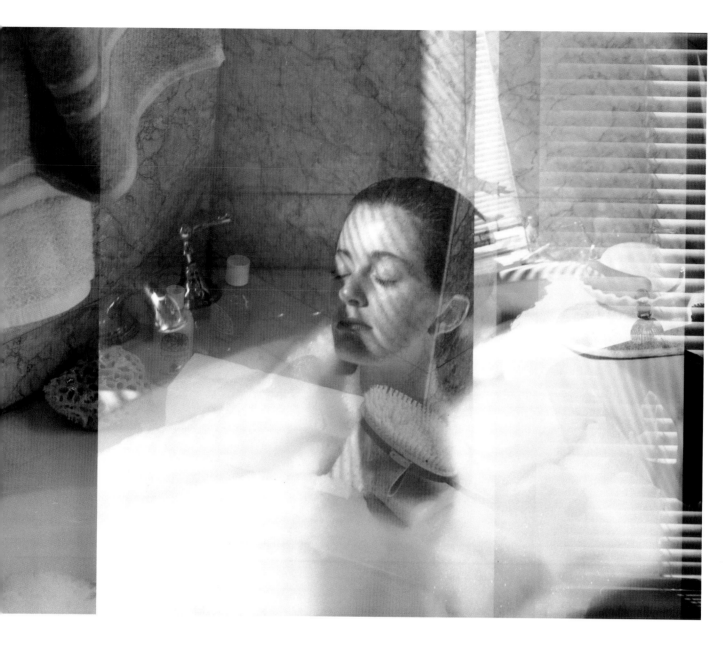

plate **97**

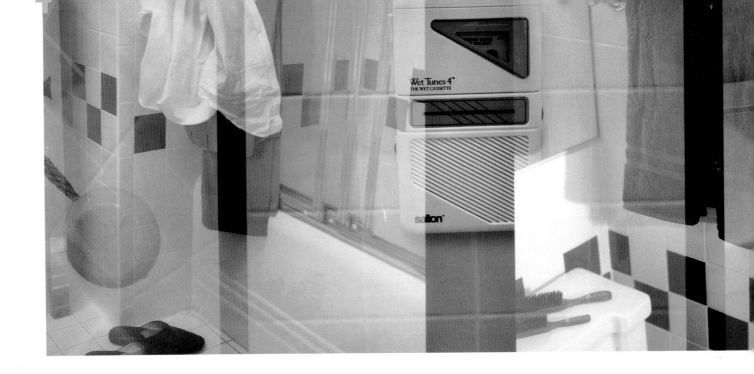

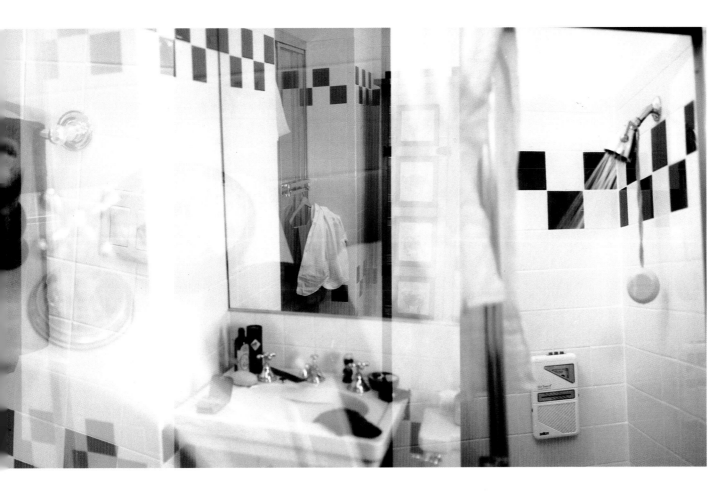

plate **98**

plate 99

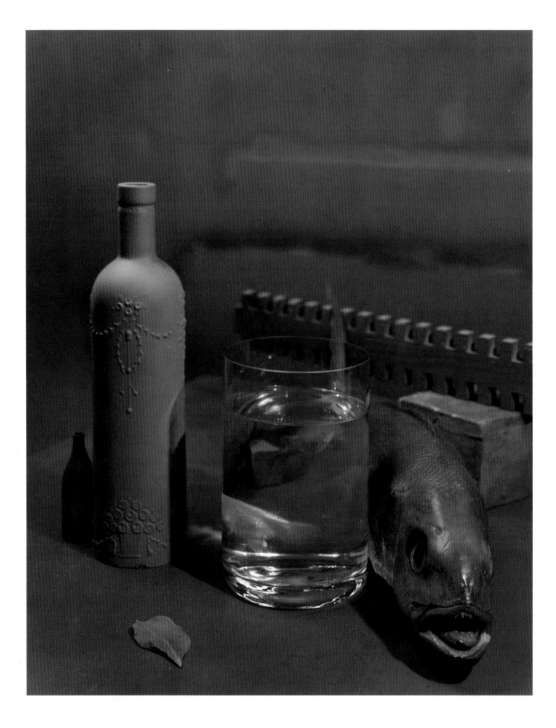

ART DIRECTOR *Sandy Di Pasqua*
PICTURE EDITOR *Phyllis Levine*
PUBLICATION *Connoisseur*
PUBLISHER *Hearst Corporation*

For "Strange New Fare,"
by Elizabeth Sahatjian, Jan Groover
captured still lifes of
exotic, edible sea creatures, including
these shots of Hawaiian
pink snapper and sea urchin. July 1987.

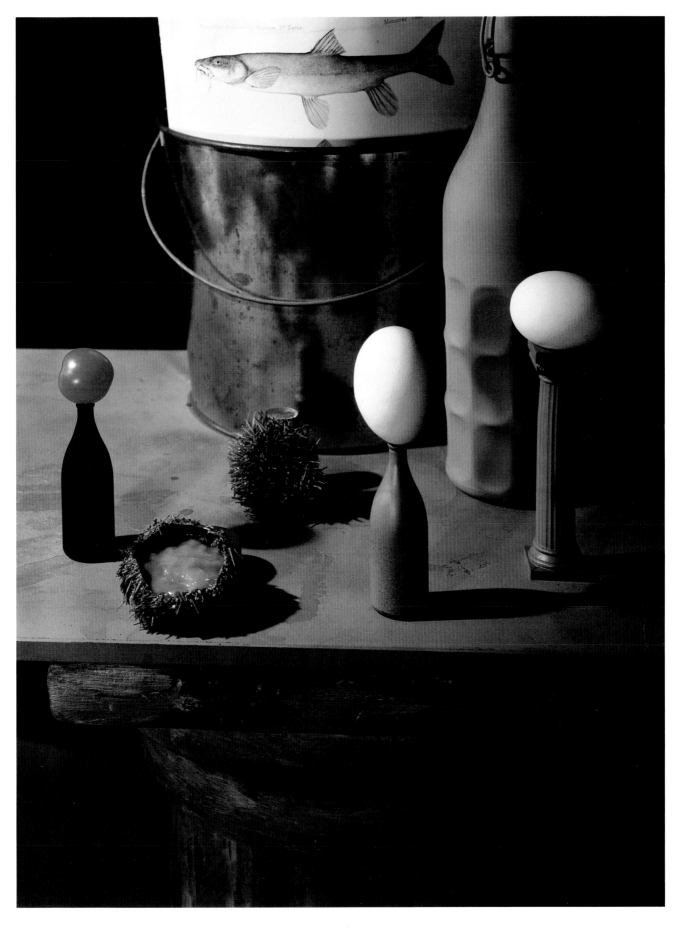

plate 100

PETE McARTHUR

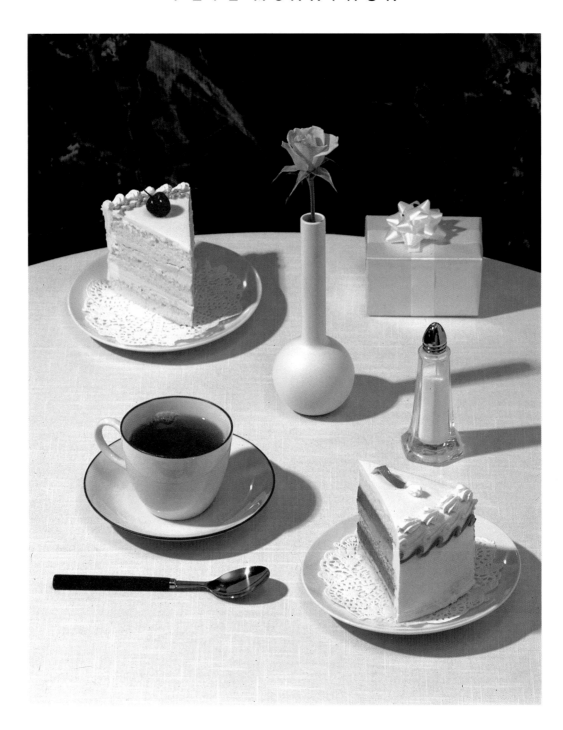

plate 101

ART DIRECTOR *Hains Wilkerson*
PICTURE EDITOR *Hains Wilkerson*
PUBLICATION *Guest Informant Magazine*
PUBLISHER *Guest Informant*

*This still life appeared in
a 1987 annual with an article about
dining out in San Francisco.*

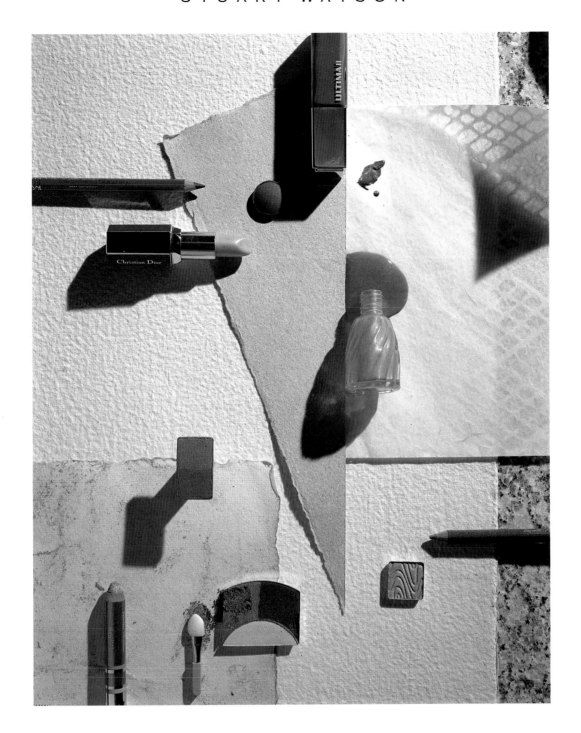

plate **102**

ART DIRECTOR *Nancy Duckworth*
PICTURE EDITOR *Alison Morley*
PUBLICATION *Los Angeles Times Magazine*
PUBLISHER *Los Angeles Times*

*"Looks," a weekly fashion
column by Paddy Calistro, featured this
still life in a piece on
make-up for the spring season. March 1987.*

JAMES WOJCIK

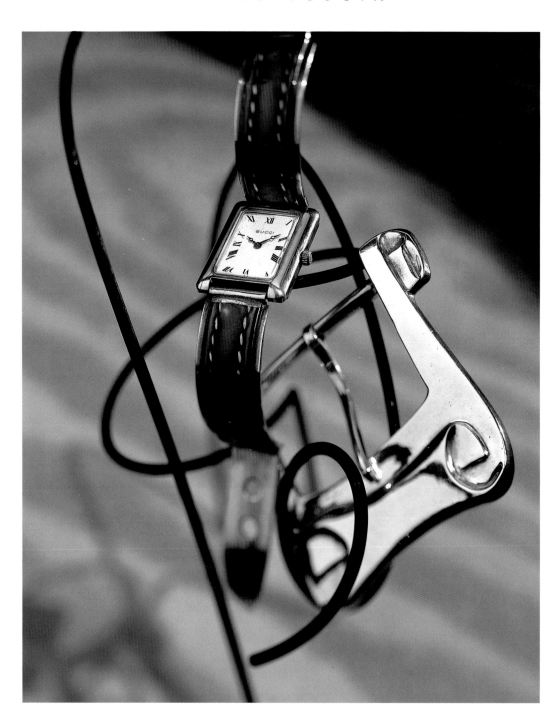

plate **103**

ART DIRECTOR *Fabien Baron*
PUBLICATION *New York Woman*
PUBLISHER *American Express Publishing*
Company

"The Spirit of Silver"
looked at fashion accessories.
November 1986.

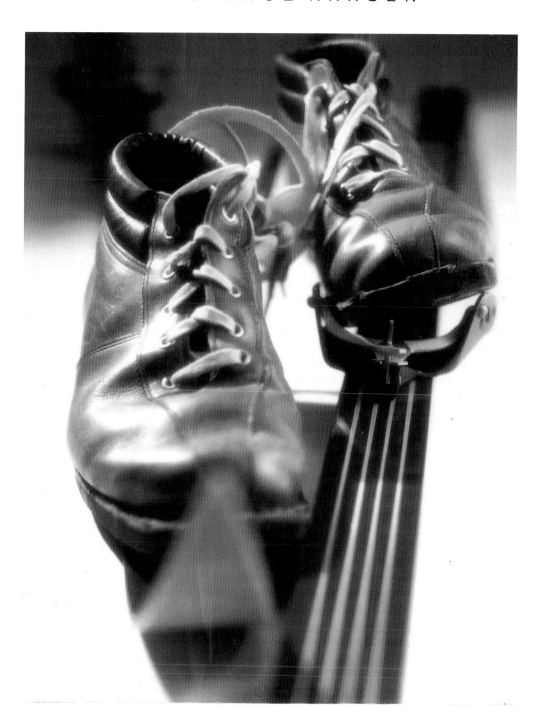

plate **104**

ART DIRECTOR *Veronique Vienne*
PICTURE EDITOR *Cathy Raymond*
PUBLICATION *Parenting Magazine*
PUBLISHER *Parenting Magazine Partners*

*A still-life polaroid
accompanied "Learning the Slopes,"
Barney Cohen's article
on sports and children. December 1987.*

ART DIRECTOR *Deb Hardison*
DESIGN DIRECTOR *Bett McLean*
PUBLICATION *Connecticut's Finest*
PUBLISHER *Whittle Communications*

The Hutterites, a
religious sect in Connecticut,
were profiled in
Susan Kissir's article "A Separate Peace."
Summer 1987.

plate **105**

plate **106**

ART DIRECTOR *David Griffin*
PICTURE EDITOR *Larry Price*
PUBLICATION *Philadelphia Inquirer Magazine*
PUBLISHER *Philadelphia Newspapers, Inc.*

*"The Enduring Glories
of the 30th Street Station," a photo essay
with text by Howard Shapiro,
profiled the famous Philadelphia train station.
December 1986.*

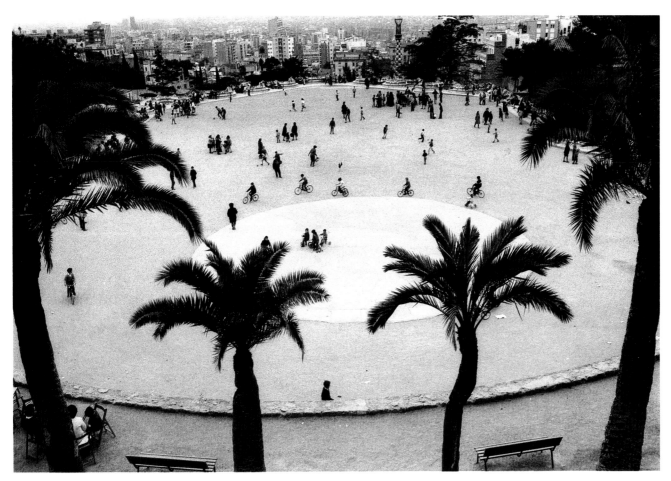

plate **107**

DESIGN DIRECTOR *Lloyd Ziff*
PICTURE EDITOR *Kathleen Klech*
PUBLICATION *Condé Nast's Traveler*
PUBLISHER *Condé Nast Publications, Inc.*

This photograph of
Barcelona accompanied Robert
Hughes's article
"Portrait of the City as Genius."
September 1987.

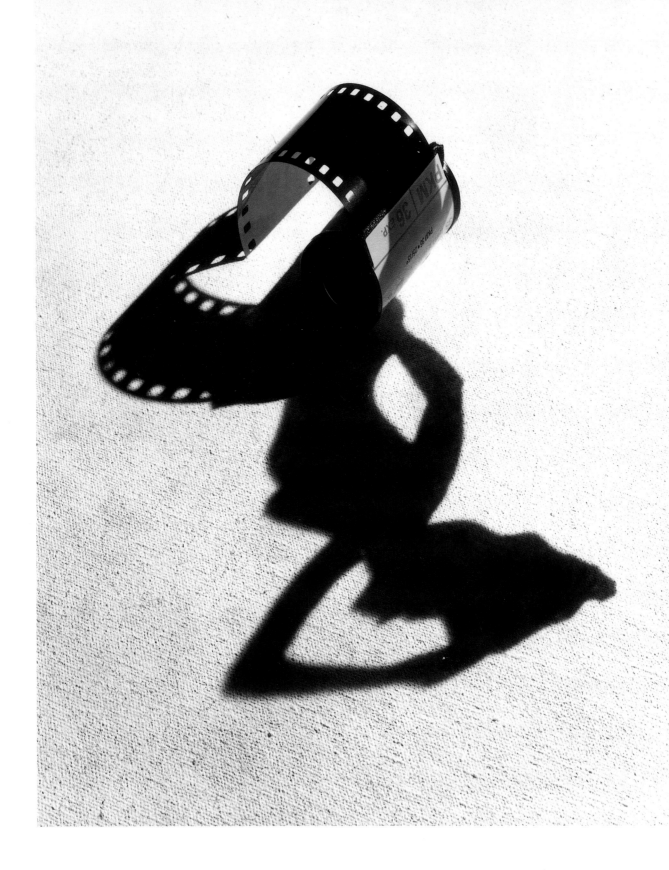

PROMOTION

Photographs

for promotional purposes,

including technical

and industrial literature,

brochures, and

self-promotion pieces

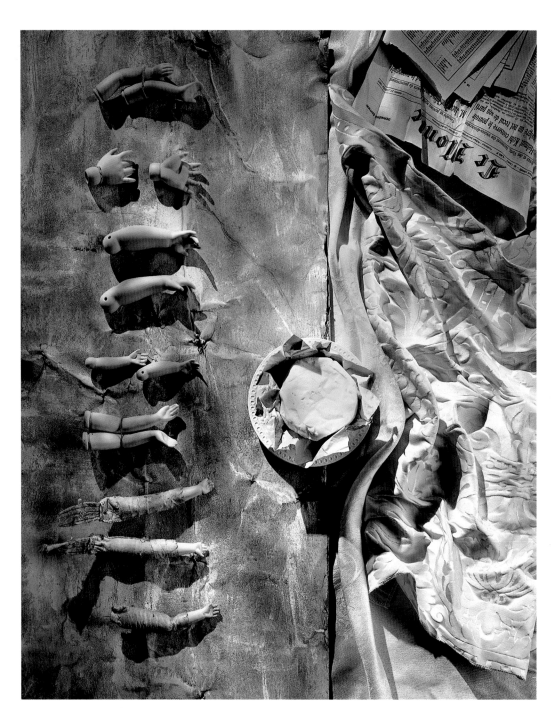

plate **108**

ART DIRECTOR *John Tennant*
PUBLISHER *Select Magazine, July 1987*

"Butter and Dolls' Hands"
and "Onions on Pink Car Door" are
part of the self-promotional
still-life photographs Hans Neleman
originally shot for the
color supplement of The Observer.

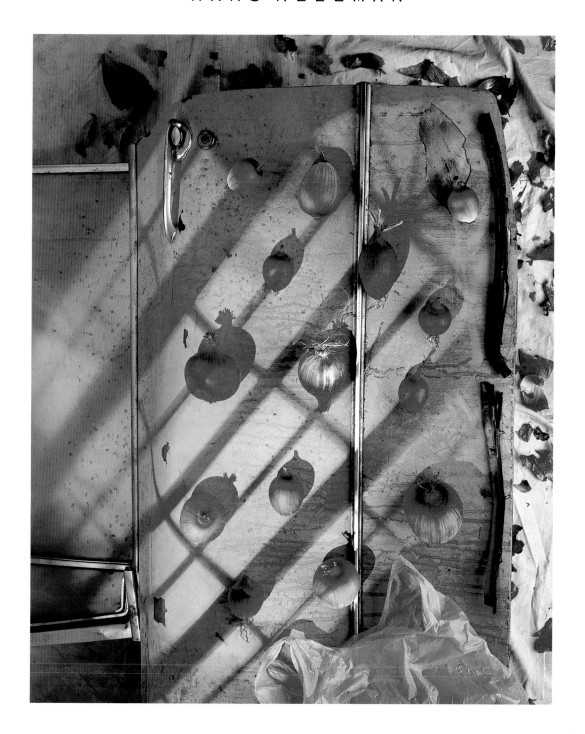

plate **109**

plate **110**

plate **111**

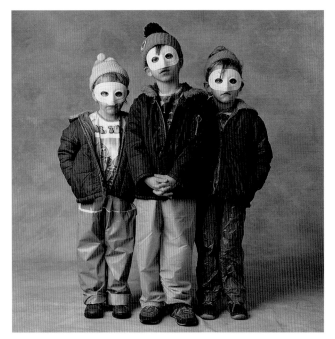 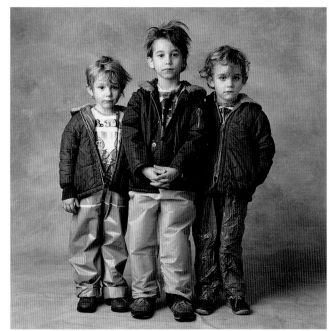

ART DIRECTOR *Bill Sosin & Associates*
DESIGN GROUP *Bill Sosin & Associates*
CLIENT *Marc Hauser/Man Mountain*
Publishing, September 1987

"Boys Wearing Masks"
and "Boys Unmasked" appeared
together on a poster
promoting Marc Hauser's book
Halloween in Bucktown.

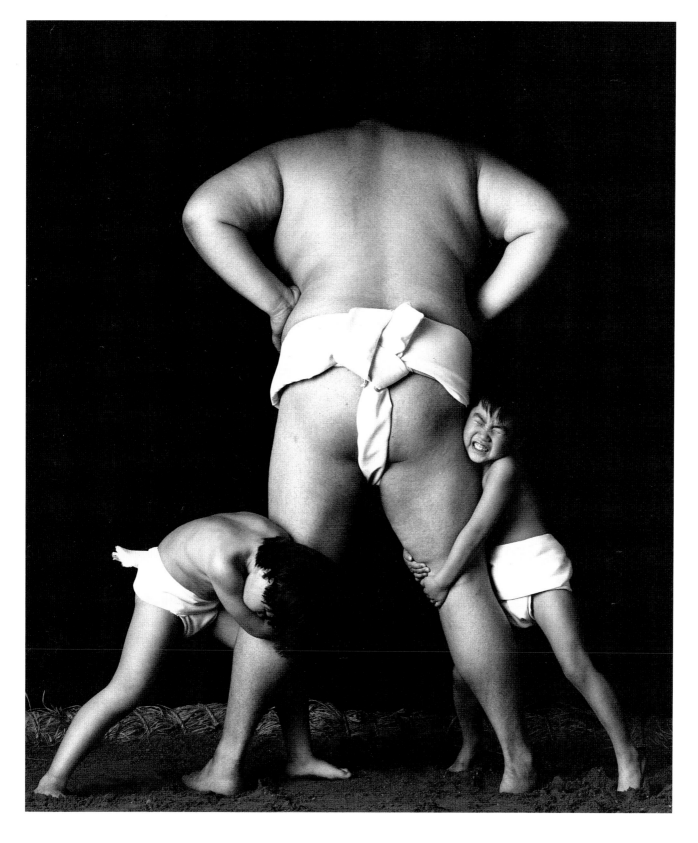

plate **112**

ART DIRECTOR *Tracy Wong*
WRITER *Michael LaMonica*
ADVERTISING AGENCY *Ogilvy & Mather, New York,*
March 1987

Ogilvy & Mather's
awards book featured this
cover photograph.

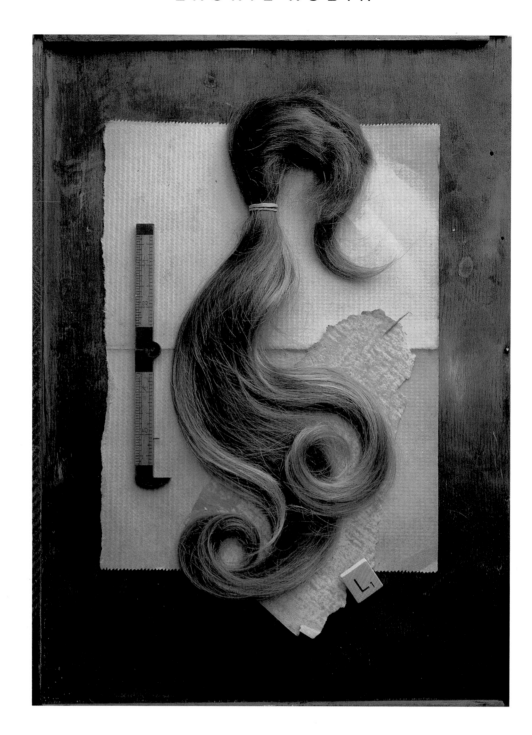

plate **113**

DESIGNER *Laurie Rubin*
PUBLISHER *Self-promotion piece, October 1987*

*"Ponytail" is part of
a self-promotion series on
personal artifacts.*

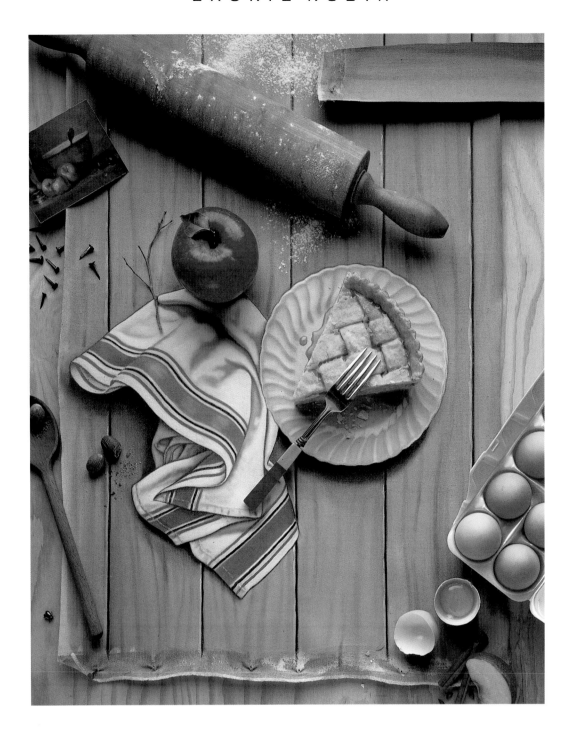

plate **114**

DESIGNER *Laurie Rubin*

Laurie Rubin used
this still-life photograph as a
self-promotion piece.

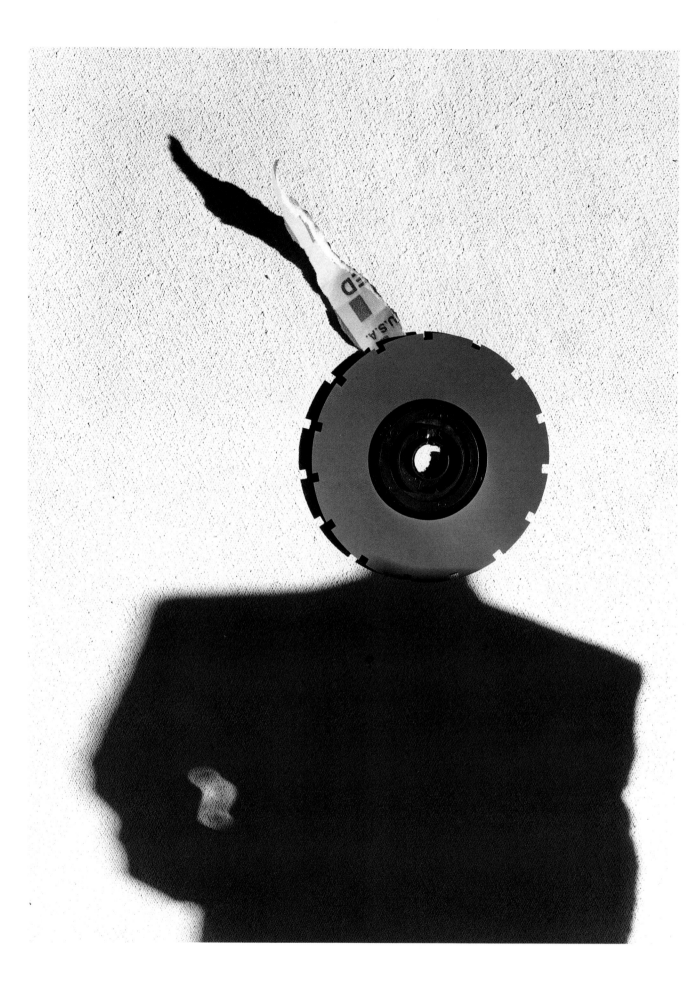

UNPUBLISHED WORK

Commissioned but

unpublished photographs,

and personal work

produced by professionals

and students

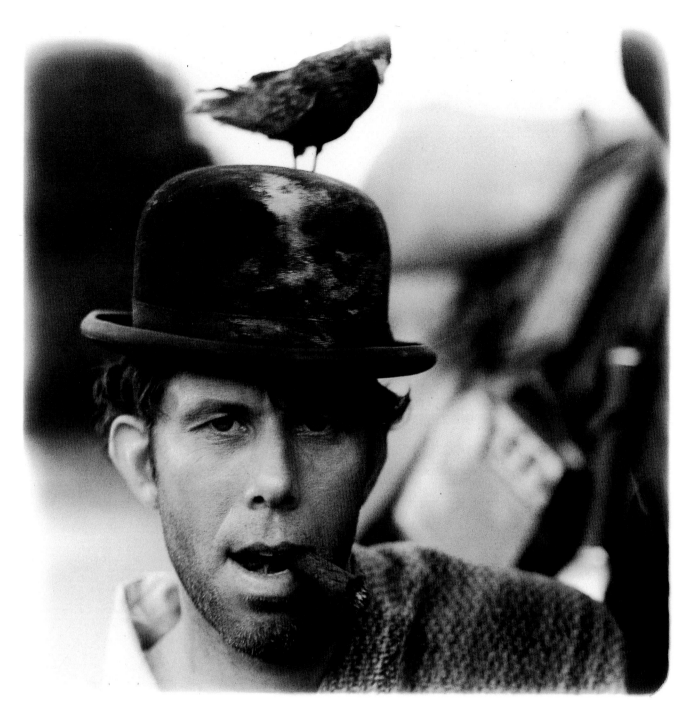

plate **115**

Matthew Rolston's portrait
of musician Tom Waits was originally
commissioned by Esquire.

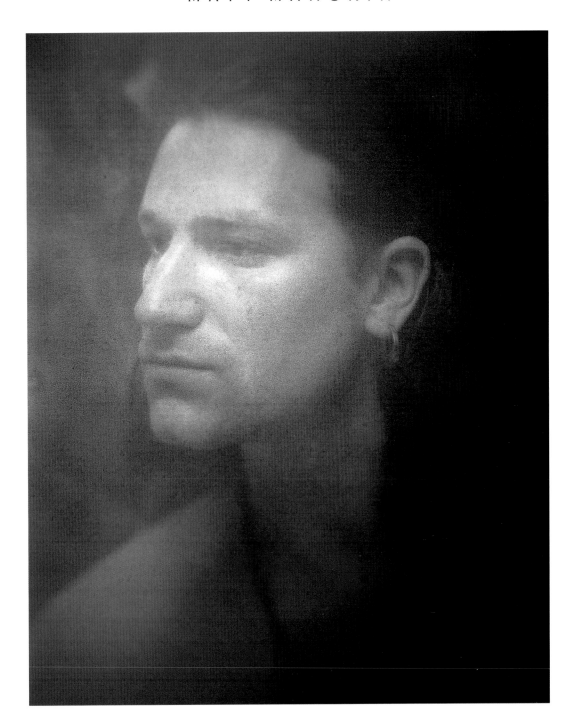

plate **116**

Matt Mahurin's
portrait of the musician Bono.

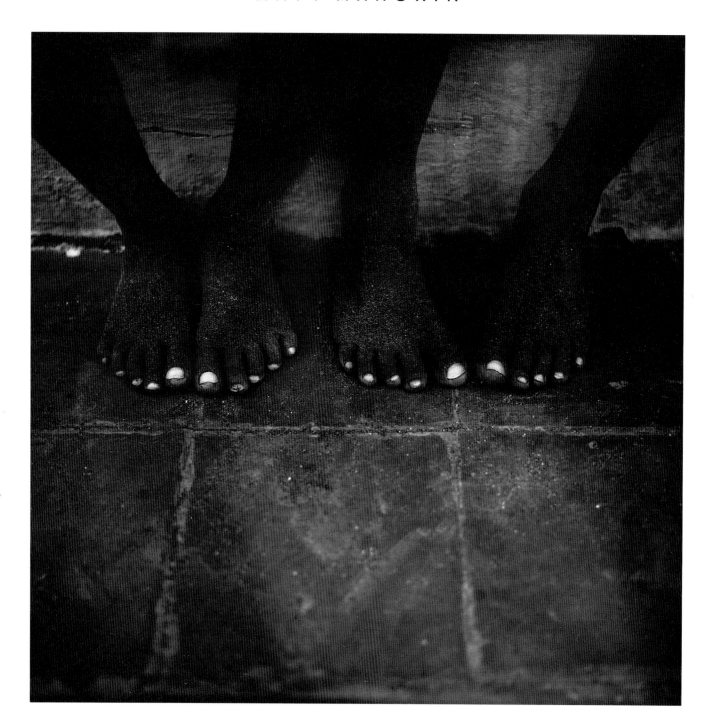

plate **117**

*This photograph is
part of the
personal series
"The Children of Nicaragua."*

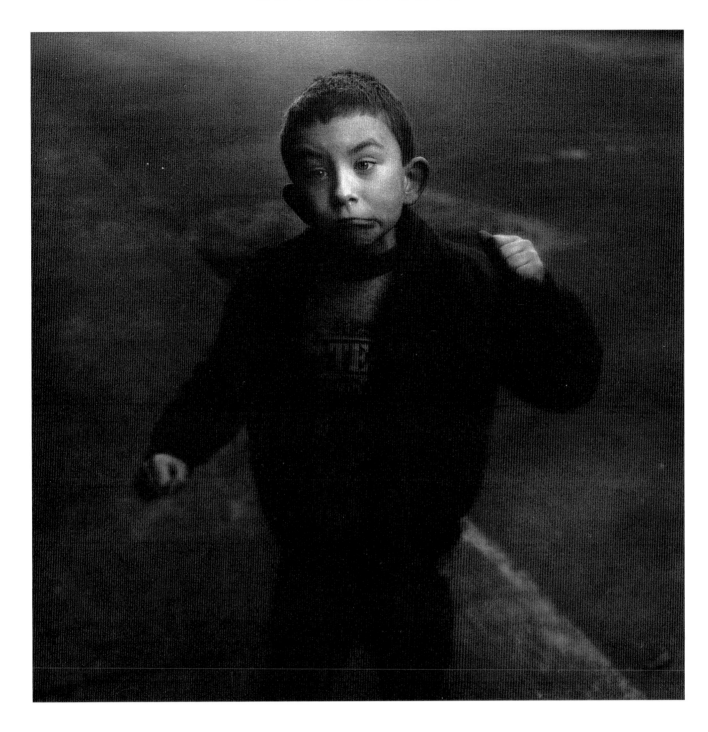

plate **118**

*Seen here are three
photographs from Matt Mahurin's
personal series
"Children of Ireland."*

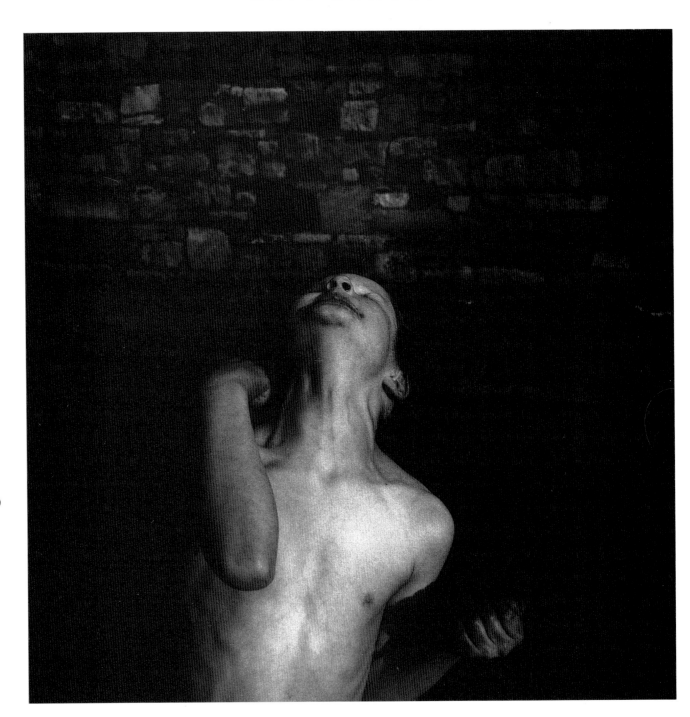

plate **119**

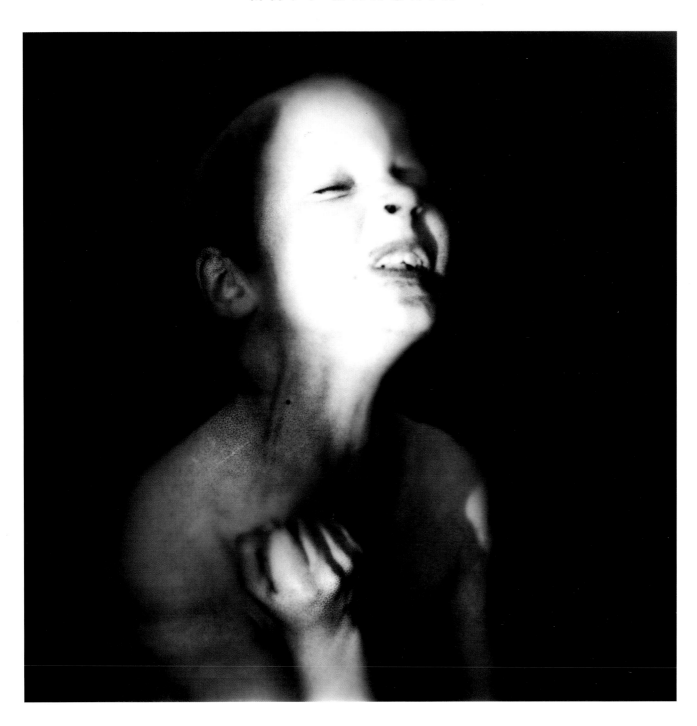

plate 120

Geoffrey Paltrowitz photographed "Indian Boys on Boat, Ganges River" during a two-month tour of India.

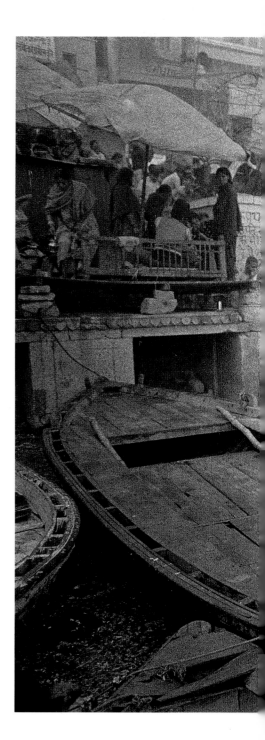

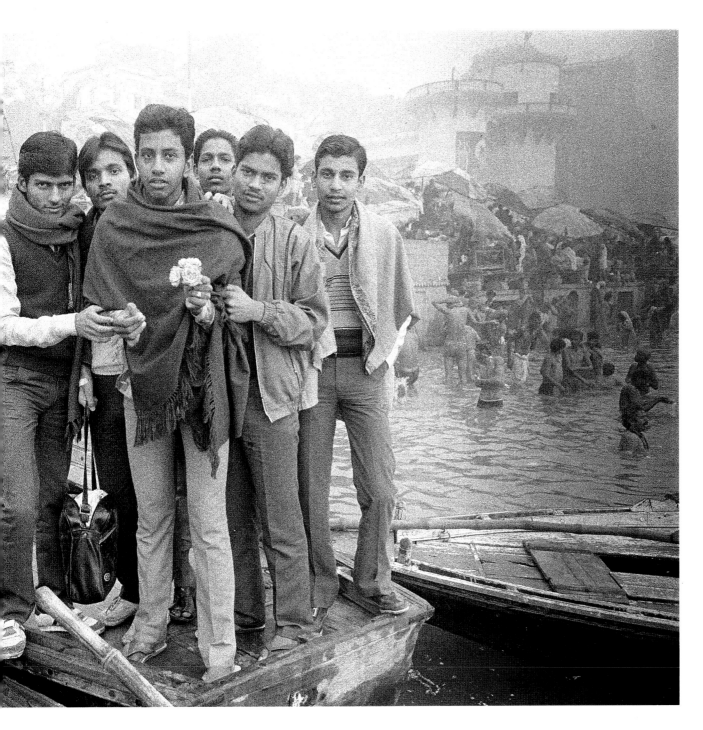

plate **121**

plate **122**

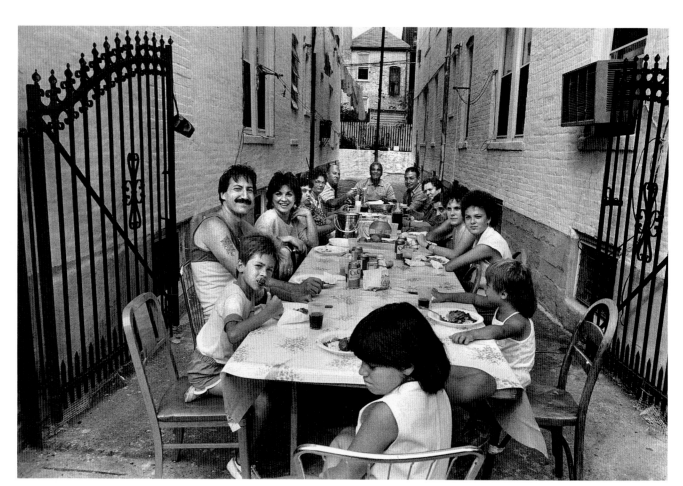

Ethel Wolvovitz shot these
two photographs, "Boy vs. Dog" and
"Sunday Alfresco," as part of
a personal series on Italian Americans
in New York City.

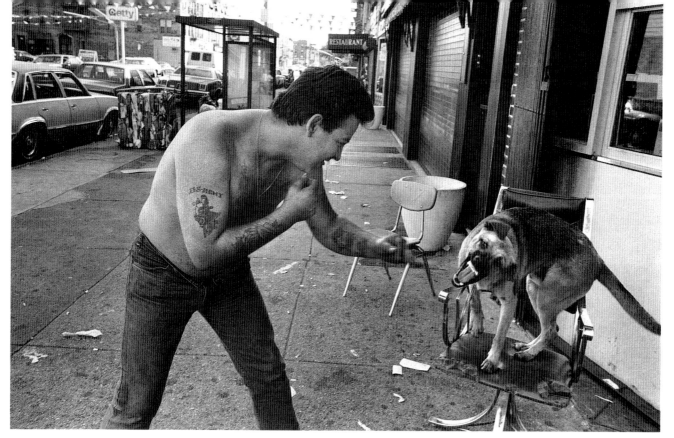

plate **123**

plate **124**

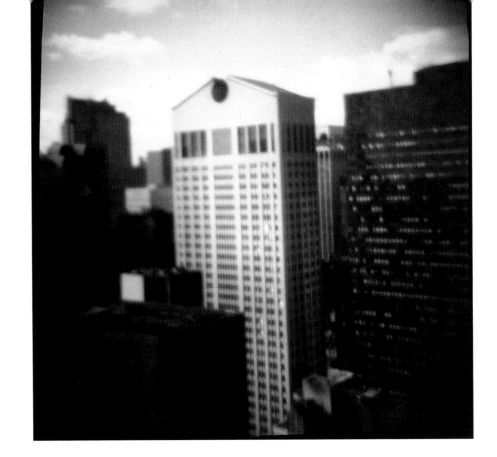

Using a Dories toy camera,
Shawn Hack shot Manhattan's
AT&T Building.

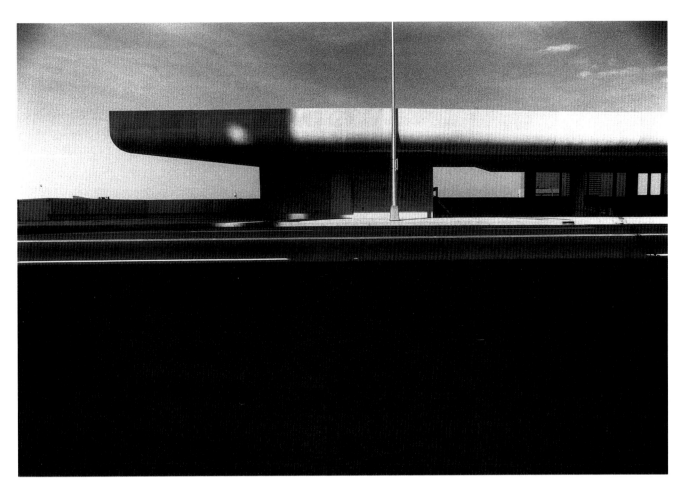

plate 125

Clark Brown's "Rail Station"
is part of an independent project.

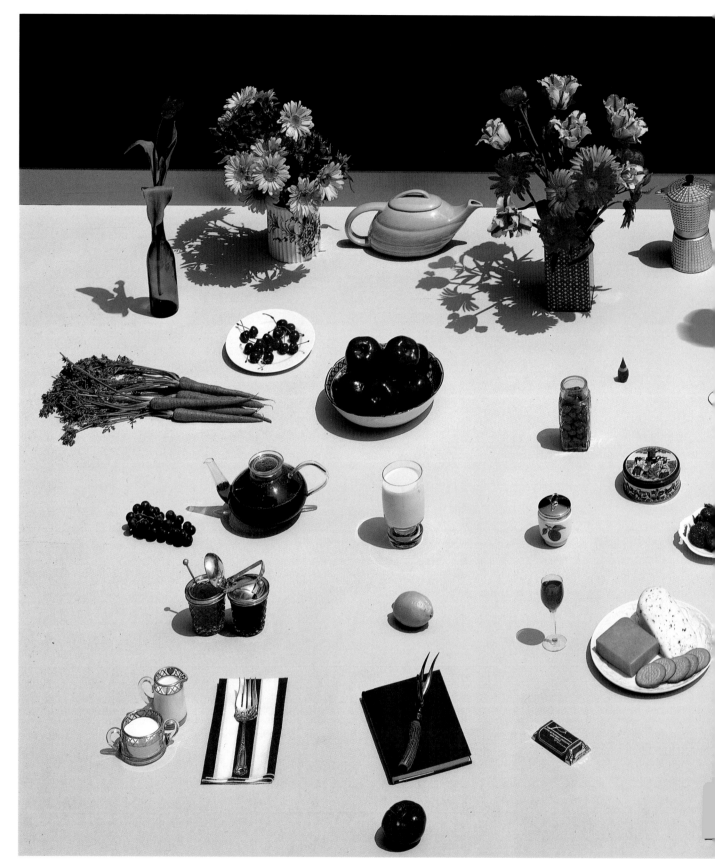

plate **126**

PETE McARTHUR

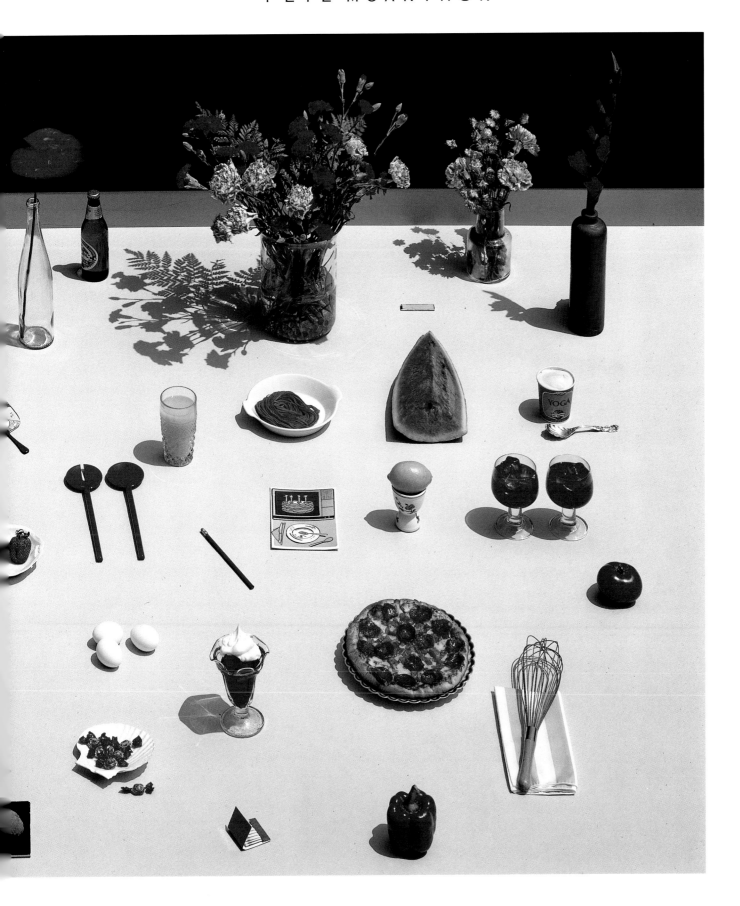

DESIGN FIRM *The Graphics Studio,*
Los Angeles

"Flavors and Fragrances"
is an outtake from a press kit cover.

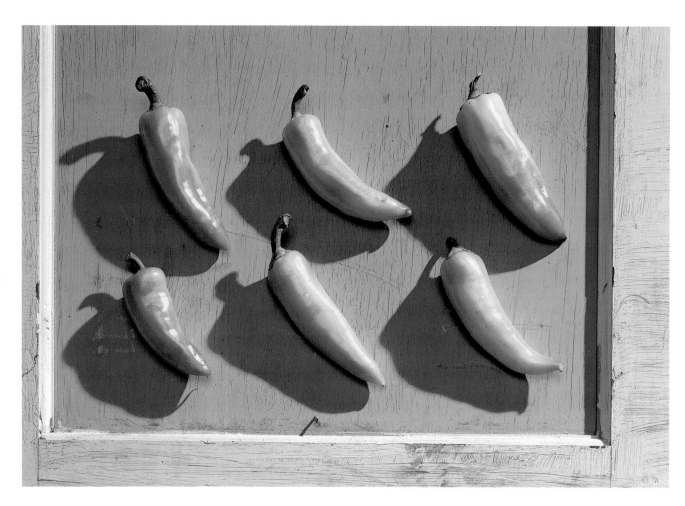

plate **127**

*"Yellow Peppers" and
"Salt & Pepper" are part of
Pete McArthur's
series of self-promotion pieces.*

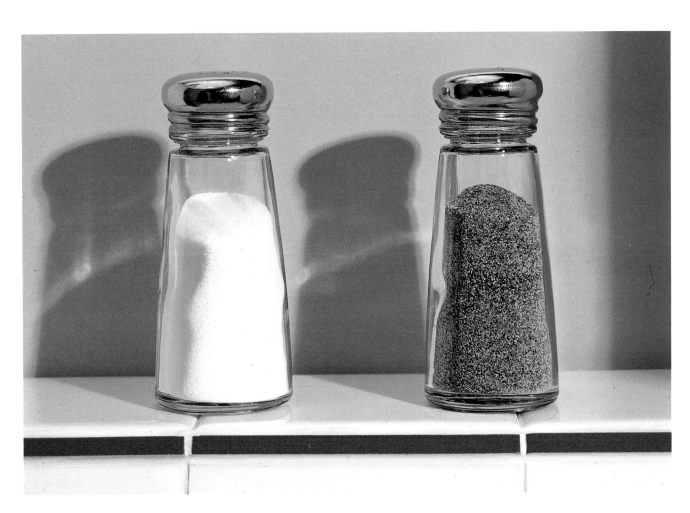

plate **128**

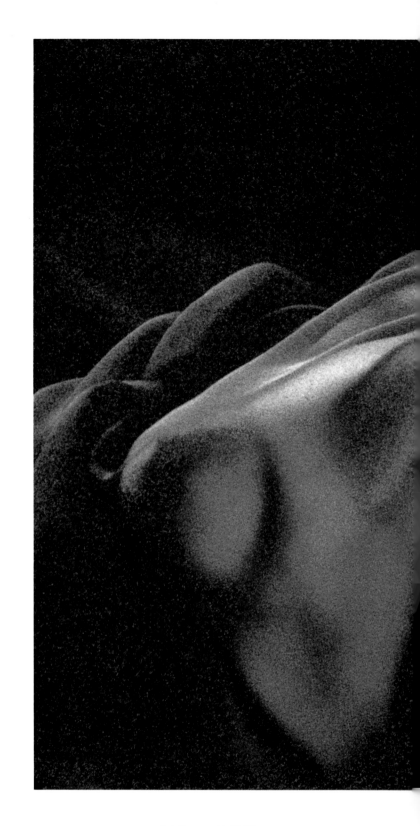

"Odalisque with Veil"
is part of a sequence of Jody Dole's
self-assigned projects.
Also shown here are "Fox Skull,"
"Futura Orchid,"
"Oub 1," "Urn," "Human Foot,"
"Stone," "Milkweed
on Slate," and "Blowfish."

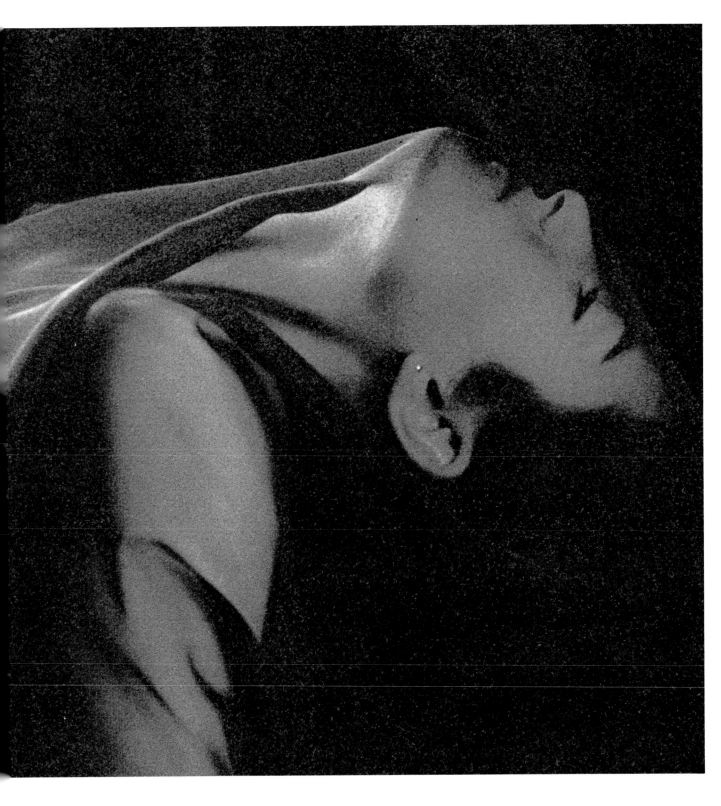

plate **129**

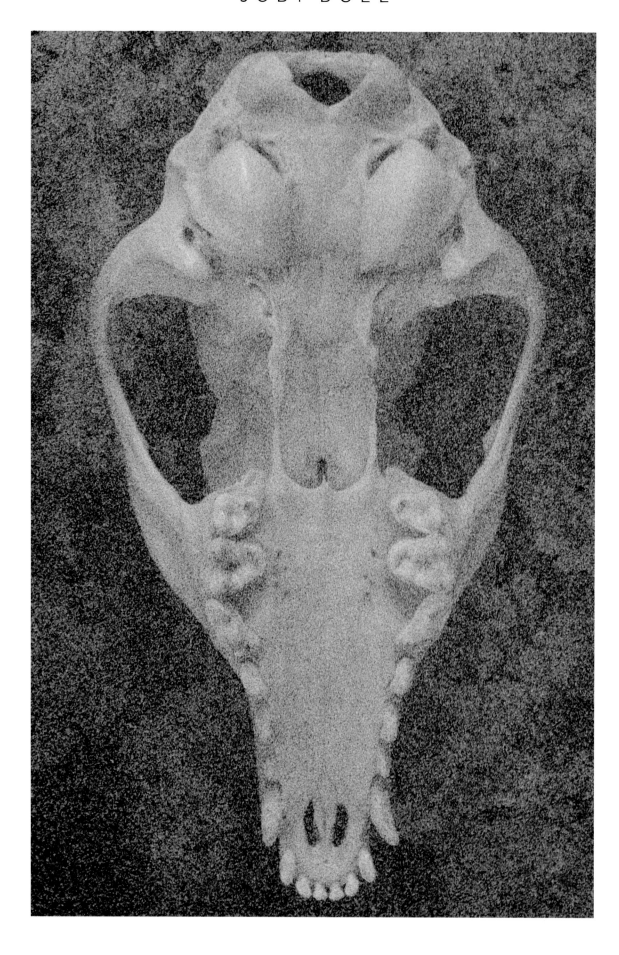

plate 130

plate **131**

plate **132**

plate **133**

plate **134**

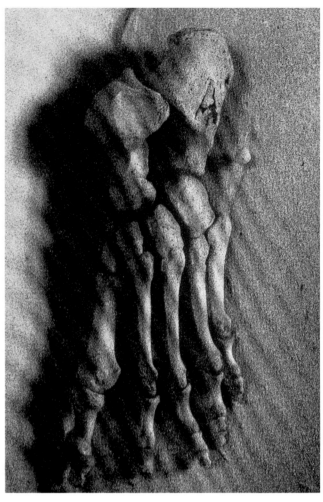

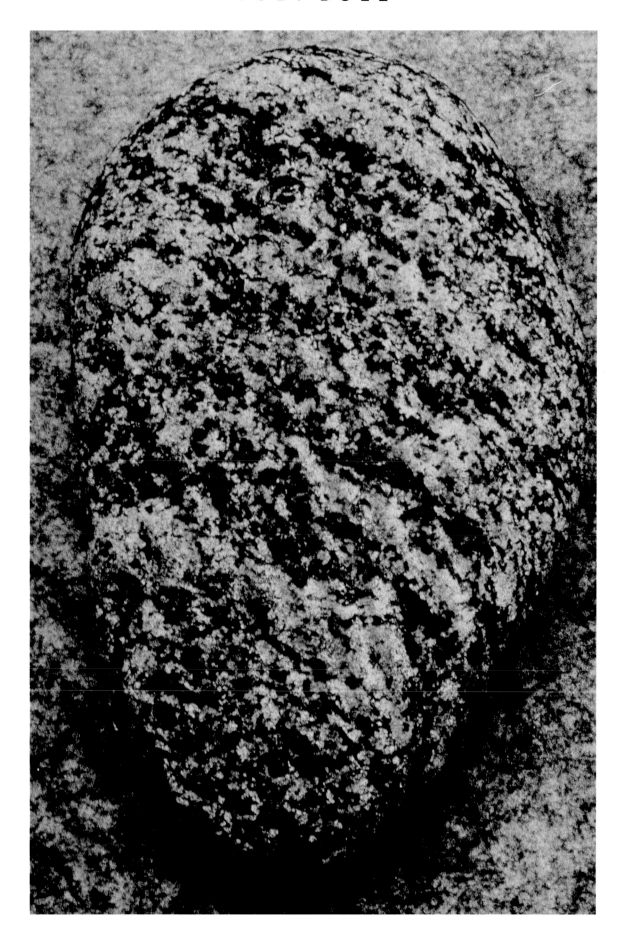

plate 135

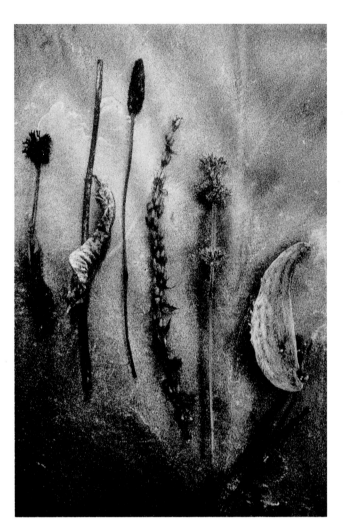

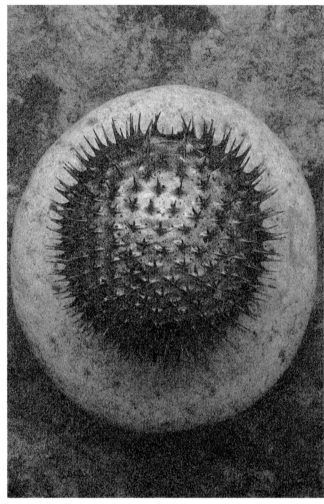

plate **136**

plate **137**

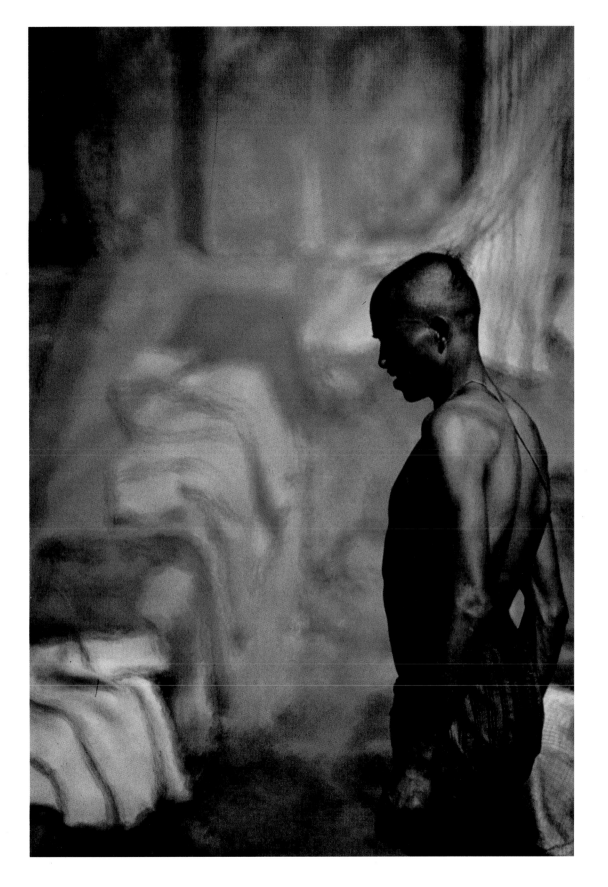

plate **138**

*"Tending the Bodies
of the Sacred Dead" is an outtake
photograph from William
Thompson's National Geographic
assignment in the
Kathmandu Valley of Nepal.*

INDEX

Names and addresses

of photographers;

names of designers,

art directors, picture editors,

editors, publications,

publishers, design groups,

advertising agencies,

and clients

PHOTOGRAPHERS

Andrea Blanch, *51–54*
434 East 52nd Street
New York, NY 10021

Clark Brown, *125*
1233 Atlantic Drive
Atlanta, GA 30318

Chris Callis, *76*
91 Fifth Avenue
New York, NY 10003

Dennis Darling, *19–21*
Department of Journalism
University of Texas
 at Austin
Austin, TX 78712

Jody Dole, *129–37*
145 East 22nd Street
New York, NY 10010

Sante D'Orazio, *56*
66 Crosby Street
New York, NY 10012

Charles Ford, *77*
32 East 22nd Street
New York, NY 10010

Jan Groover, *99–100*
189 Bowery
New York, NY 10002

Sandra Haber, *97–98*
458 Broadway
New York, NY 10013

Shawn Hack, *124*
7 Doubling Road
Greenwich, CT 06830

Constance Hansen, *104*
31 West 34th Street
New York, NY 10013

Marc Hauser, *22–23,*
 110–11
1810 West Cortland
Chicago, IL 60622

Robb Kendrick, *105*
2760 Albany, Suite 303
Houston, TX 77006

Geof Kern, *24–25, 26,*
 27, 28
1337 Crampton
Dallas, TX 75207

David Langley, *112*
536 West 50th Street
New York, NY 10019

Annie Leibovitz, *1–5*
101 West 18th Street
New York, NY 10011

Jean-François Lepage,
 78–85, 86–94
20 Rue Rohechouart
Paris 75009
France

Matt Mahurin, *44–46,*
 47, 48, 49, 50, 116, 117,
 118–20
77 Bleecker Street, #102
New York, NY 10012

Mary Ellen Mark, *63,*
 64–68, 69
143 Prince Street
New York, NY 10012

Kurt Markus, *12–14, 15–18*
9555 Bennison Terrace
Colorado Springs,
CO 80908

Pete McArthur, *101, 126,*
 127–28
2867 West 7th Street
Los Angeles, CA 90005

Edward McCain, *60*
756 North Palo Verde
 Avenue
Tucson, AZ 85716

Raymond Meier, *95–96*
532 Broadway
New York, NY 10012

Sheila Metzner, *6–11*
310 Riverside Drive
New York, NY 10025

Hans Neleman, *108–9*
348 West 14th Street
New York, NY 10014

Jeff Newbury, *57–59*
16 Dodge
San Francisco, CA 94102

Geoffrey Paltrowitz, *121*
420 West 23rd Street, #3C
New York, NY 10011

Denis Piel, *55*
72 Spring Street
New York, NY 10012

Steven Pumphrey, *61, 62*
1309 Richcreek Road
Austin, TX 78757

Herb Ritts, *34, 35, 36, 37,*
 38–39
7927 Hillside Avenue
Los Angeles, CA 90046

Matthew Rolston, *30–31,*
 32, 33, 115
8259 Melrose Avenue
Hollywood, CA 90046

Laurie Rubin, *113, 114*
1113 Armitage
Chicago, IL 60614

Chip Simons, *75*
26 West 27th Street
New York, NY 10011

Neal Slavin, *74*
62 Greene Street
New York, NY 10012

William Thompson, *138*
P.O. Box 4460
Seattle, WA 98104

Michael Tighe, *72–73*
110 East 1st Street
New York, NY 10009

Will van Overbeek, *70,71*
305 East Sky View
Austin, TX 78752

Stuart Watson, *102*
620 Moulton Avenue
Los Angeles, CA 90031

David H. Wells, *106*
668 North 19th Street
Philadelphia, PA 19130

James Wojcik, *103*
256 Mott Street
New York, NY 10012

Ethel Wolvovitz, *122–23*
305 Ocean Parkway
Brooklyn, NY 11218

Lloyd Ziff, *107*
114 East 32nd Street,
 Suite 1103
New York, NY 10016

ART DIRECTORS

Mark Balet, *34*
Fabien Baron, *47, 78–85,*
 86–94, 103
Nancy Butkus, *76*
Dennis Darling, *19–21*
Sandy Di Pasqua, *99–100*
Nancy Duckworth, *102*
Rip Georges, *38–39, 56*
David Griffin, *106*
Deb Hardison, *105*
Wendall Harrington, *33,*
 57–59, 72–73, 75
Peter Howe, *63*
Geof Kern, *27*
Bett McLean, *105*
Parry Merkley, *1–5*
Don Morris, *97–98*
Tohji Murata, *6–8*
Tomohiko Nagakura, *9–11*
Brian Noyes, *69, 74*
Kerig Pope, *50*
Herb Ritts, *37*
Mary Shanahan, *55*
Bill Sosin & Associates, *22–23,*
 110–11
D. J. Stout, *24–25, 28, 71*
Hisao Sugiura, *12–14*
John Tennant, *108–9*
Derek Ungless, *29, 51–54*
Veronique Vienne, *104*
Hains Wilkerson, *101*
Tracy Wong, *112*
Fred Woodward, *30–31,*
 32, 35, 36, 44–46, 48, 49,
 61, 62, 77
Lloyd Ziff, *40–43, 107*

DESIGNERS

Eleanor Caponigro, *15–18*
Dennis Darling, *19–21*
Laurie Rubin, *113, 114*
Bill Sosin & Associates, *22–23*

WRITERS

Gordon Bowen, *1–5*
Michael LaMonica, *112*

PICTURE EDITORS

Lisa Atkin, *55*
Maureen Benziger, *70*
Lucy Handley, *57–59*
Peter Howe, *63*
Kathleen Klech, *40–43, 107*
Laurie Kratochvil, *29, 30–31,*
 32, 36, 48, 49
Phyllis Levine, *99–100*
Nancy E. McMillen, *71*
Alison Morley, *102*
William Nabers, *97–98*
Larry Price, *106*
Cathy Raymond, *104*
Michael Roberts, *37*
Molly Roberts, *69, 74*
Laurie Schecter, *51–54*
Temple Smith, *33, 72–73, 75,*
 95–96
Hains Wilkerson, *101*
P. K. Weis, *60*

EDITORS

Russell Martin, *15–18*
Dana Scragg, *19–21*
Susan Stone, *19–21*

DESIGN GROUPS

The Graphics Studio, *126*
Bill Sosin & Associates, *110–11*
Strawberry Fields, *6–8*
Studio Super Compass, *12–14*

ADVERTISING AGENCIES

Ogilvy & Mather, *1–5, 112*

CLIENTS

American Express, *1–5*
Marc Hauser/Man Mountain
 Publishing, *110–11*
Sutseso, *6–11*
Yohji Yamamoto, *12–14*

PUBLICATIONS

Condé Nast's Traveler,
 40–43, 107
Connecticut's Finest, *105*
Connoisseur, *99–100*
Detour Magazine, *27*
Esquire, *33, 57–59, 72–73, 95–96*
Fortune Magazine, *70*
Gentleman's Quarterly, *55*
Guest Informant Magazine, *101*
Homeless in America, *64–68*
Interview Magazine, *34*
L.A. Style, *38–39, 56*
Life Magazine, *63*
Los Angeles Times Magazine,
 102
Manhattan, Inc., *76*
Metropolitan Home, *97–98*
New York Woman, *47, 78–85,*
 86–94, 103
Parenting Magazine, *104*
Philadelphia Inquirer
 Magazine, *106*
Playboy, *50*
Regardie's Magazine, *44–46, 77*
Rolling Stone, *26, 29, 30–31,*
 32, 36, 48, 49, 51–54
Tatler, *37*
Texas Monthly, *24–25, 28, 61,*
 62, 71
Tucson Citizen, *60*
Washington Post Magazine,
 69, 74

PUBLISHERS

American Express Publishing
 Company, *47, 78–85, 86–94,*
 103
Andy Warhol Enterprises, *34*
Citizen Publishing Company, *60*
Condé Nast Publications, Inc.,
 37, 40–43, 55, 107
Detour Magazine, Inc., *27*
Dosoduro Press, *19–21*
Guest Informant, *101*
Hearst Corporation, *33, 57–59,*
 72–73, 75, 95–95, 99–100
L.A. Style, Inc., *38–39, 56*
Little, Brown and Company,
 Inc., *15–18*
Los Angeles Times, *102*
Manhattan Magazine, Inc., *76*
Man Mountain Publishing,
 22–23
Meredith, *97–98*
Parenting Magazine Partners,
 104
Philadelphia Newspapers, Inc.,
 106
Playboy Enterprises, Inc., *50*
Regardie's Magazine, Inc.,
 44–46, 77
Select Magazine, *108–9*
Straight Arrow Publishers, Inc.,
 26, 29, 30–31, 32, 36, 48,
 49, 51–54
Texas Monthly, Inc., *24–25,*
 28, 61, 62, 71
Time, Inc., *63, 70*
Washington Post Company,
 69, 74
Whittle Communications, *105*

BOOKS

"Buckaroo" Images from the
 Sagebrush Basin, *15–18*
Desperate Pleasures, *19–21*
Halloween in Bucktown, *22–23*